IMAGES
of America

HUDSON
NEW HAMPSHIRE

IMAGES
of America

HUDSON
NEW HAMPSHIRE

Laurie A. Jasper

ARCADIA

First printed in 2000.
Reprinted in 2000.

Published by Arcadia Publishing,
an imprint of Tempus Publishing, Inc.
2A Cumberland Street
Charleston, SC 29401

Printed in Great Britain.

For all general information contact Arcadia Publishing at:
Telephone 843-853-2070
Fax 843-853-0044
E-Mail sales@arcadiapublishing.com

For customer service and orders:
Toll-Free 1-888-313-2665

Visit us on the internet at http://www.arcadiapublishing.com

CONTENTS

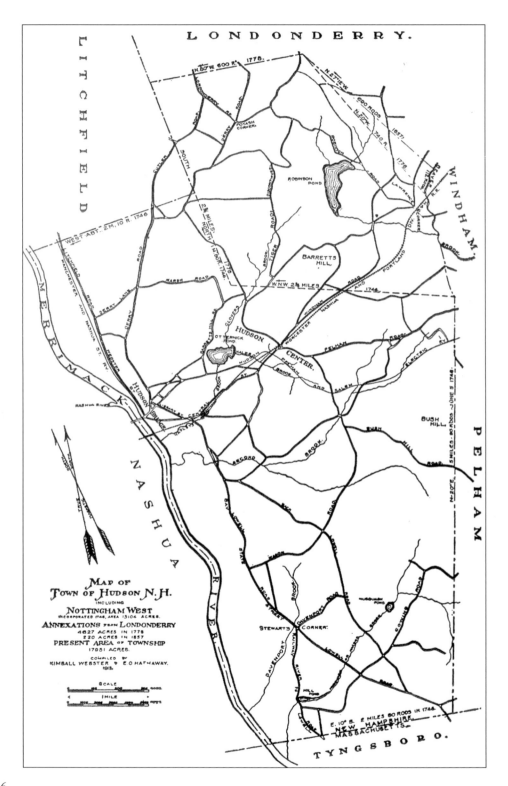

INTRODUCTION

The town now known as Hudson, New Hampshire, is a town of approximately 24,000 residents located in southern New Hampshire. Hudson is bordered by Litchfield and Londonderry, New Hampshire, on the north, Windham and Pelham, New Hampshire, on the east, Tyngsborough, Massachusetts, on the south, and Nashua, New Hampshire, on the west.

Hudson was a part of Dunstable, Massachusetts, from 1673 to 1733, then was a part of Nottingham, Massachusetts, from 1741 to 1746, then Nottingham West, New Hampshire, from 1746 to 1830, and finally became the town of Hudson, New Hampshire, in 1830. Along with the name changes, the town has also endured changes to its center. Hudson does not have a typical downtown location that one often finds in communities. In fact, Hudson has two "centers." Downtown areas were built in convenient parts of towns and became their hearts, with the stores, post offices, town offices, churches, and libraries all clustered within the downtown for convenience. Before 1913, Hudson's "downtown" was Hudson Center, now the area of Route 111 by Central Street and Greeley Street. This area was home to the post office, the railroad station, and other businesses. However, as the town began to grow and transportation improved, The Bridge area or Post Office Square, now the area at Ferry Street, became Hudson's downtown. This area was closer to the city of Nashua, New Hampshire, and to more opportunities for the residents of this small farming community.

Hudson continued to grow and prosper, and developed into a household name by becoming the home of Benson's Wild Animal Farm. Its founder John T. Benson was born in England, but came to the United States to perform as a young animal trainer. He then became an animal scout, searching the world for exotic and wild animals for acts all over the country. He helped establish the Franklin Park Zoo in Boston, Massachusetts, and purchased the property on Kimball Hill Road in Hudson as the stopping point and quarantine spot for his finds. The Strangest Farm on Earth, as it was nicknamed, was opened to the public in 1926, and Benson started to promote the location as a tourist stop, mainly to help with the cost of taking care of the animals. Mr. Benson died in 1943, and the farm was sold to a group of men who were affiliated with the Boston Garden in Massachusetts. The farm continued to expand under the new owners and included many amusement rides. Benson's was sold again in 1979 and finally closed forever in 1987, though many locals still have fond memories of their trips to Benson's. The land is currently owned by the State of New Hampshire.

One of the earliest families to settle in the area known as Hudson was the Hills family. Dr. Alfred Kimball Hills was a direct descendant of the original settlers and became one of the

town's most prominent citizens and benefactors. In fact, the town of Hudson owes a large debt of gratitude to Dr. Hills for his generosity. Dr. Hills was born in 1840 in Hudson, became a doctor, and moved to New York. In 1887, he wed Ida Virginia Creutzborg and purchased land in Hudson from his father, on which he built a summer home in 1890. This home was called "Alvirne," a combination of the names Alfred and Virginia. Dr. and Mrs. Hills spent their summers in Hudson at Alvirne and then returned to New York for the winter months. The couple had two daughters, but both died in infancy. Sadly, Mrs. Hills died suddenly in 1908. Dr. Hills and his mother-in-law, Mrs. Creutzborg, had the Hills Memorial Library built in memory of Mrs. Hills to honor her and her great love of books. The library was built by the same architect with whom she had designed the library addition to Alvirne in 1891, and many of Mrs. Hills touches were added to the town's library. Dr. Hills also purchased land and dedicated Library Park to the town to preserve this pretty parcel of land near the library. When Dr. Hills died in 1920, he remembered the town of Hudson in his will. Dr. Hills wished the Town of Hudson would build an "industrial" school, or what is known today as an agricultural school. Thus, Hudson was able to construct Alvirne High School in 1950. Begun in 1948, the school was built just in time to correspond with the time frame spelled out in Dr. Hills's will. Jessie Norwell Hills died in 1963 and Alvirne Hills House was left vacant, vandalized, and almost was torn down. However, in 1966, the Hudson Historical Society was formed to save the home and preserve it as a museum for Hudson, incorporating donations from residents also concerned with preserving Hudson's heritage.

As the population of Hudson continues to increase today, school overcrowding solutions are presently being discussed. This was also the case when Hudson was a much smaller community. One-room schoolhouses were built throughout the town, the last one being the Number Nine Schoolhouse on the present Old Derry Road, which was built in 1886 and remained open until 1932. This schoolhouse was the last one-room schoolhouse to operate in the town, and the last to remain in its original condition today. The one-room schoolhouses were closed and larger schools were built. In times of severe space shortage, classes were held in Odd Fellows Hall, churches, and even the fire station. High school students attended Nashua High School until Alvirne High School was built in 1950. Only nine years later, in 1959, an eight-room addition and a vocational/agricultural building were built at the high school. In 1970, a plan was adopted to allow high school students to attend high school in quarters, including the summer, to alleviate overcrowding and allow more in-depth studies. Students could enroll in all four quarters and graduate early, or opt to take one quarter off, and summer quarters were optional. This plan is no longer in place. In 1974, Alvirne High School was destroyed by fire, but was rebuilt one year later.

The town's fire and police departments have also expanded as they continue to provide Hudson with excellent protection. The fire department, once all volunteers, now has a full complement of full-time firefighters and EMTs at Central Fire Station. It also continues to utilize call members at all three of its fire stations. This is a long way from a time when the fire department had to share its quarters with a garage and the police department. The police department has also grown to meet the needs of the town, and in 1995, a spacious new facility was built on Constitution Drive.

I hope that all who read this book enjoy it. The pictures really do tell the story of Hudson. It is my hope that the Hudson Historical Society will continue to be able to preserve Hudson's past for the benefit of Hudson's future. I also encourage each person to become his or her own family archivist and begin today to preserve photos, stories, and memories in safe, protective books, and to label your pictures for future generations.

ACKNOWLEDGMENTS

I am grateful to the members of the Hudson Historical Society, past and present, who have preserved so much of Hudson's history through pictures, words, and memorabilia. Alvirne Hills House archives hold a wealth of knowledge about Hudson, but without the forethought and dedication of members and donors these valuable treasures might have been lost. This book is comprised largely of photographs from the Society's collection. I am also indebted to the late Kimball Webster. Although he died in 1916, he contributed greatly to the written parts of this book through his *History of Hudson, New Hampshire*, which he spent 50 years of his life compiling and which continues to be the main source of information about the town. His careful attention to detail amazes me each time I open his book.

Special thanks are extended to those who shared their photos, stories, and remembrances including: George Benson for several school photos; Pauline (Smith) Leclerc Blais for her wonderful collection of Benson's Wild Animal Farm pictures; Leon Hammond for his time; The Hudson Fire Department and in particular David Morin for the great pictures; Robert and Reita Jasper for the Farm pictures; Esther McGraw for her photos and great memory; Emery Nadeau Sr. for the Farm pictures; John Simo for some school pictures; Claire Smith for her wonderful memory and kindness.

Thanks, also, to my family, including my husband, Shawn; parents Jack and Jean Ann Lyons; sister Christie Lyons, brother and wife Jay and Caroline Lyons and niece Anne Lyons for their encouragement. My first publication was supposed to be the great novel, but that will have to wait.

Finally, this book is dedicated to my Sarah with love.

One

DR. HILLS AND HIS LEGACIES

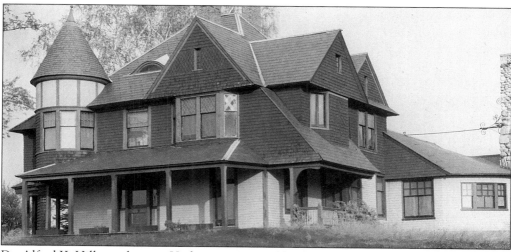

Dr. Alfred K. Hills was born in Hudson in 1840 and became one of the chief benefactors of the town. "Alvirne" Hills House was built in 1890 by Dr. Hills and his second wife Ida Virginia (Creutzborg) Hills as their summer home. They resided in New York during the winter months. The 17-room Victorian home was named Alvirne as a combination of their names. Ida Virginia Hills died suddenly at age 51 in 1908. Dr. Hills married his third wife Jessie Norwell Hills in 1910. He died in 1920 and Jessie Hills continued to summer at Alvirne until her death in 1963, when the home was boarded up, left vacant, and targeted by vandalism. The home was almost torn down until a group of concerned citizens formed the Hudson Historical Society in 1966 and took on the renovation of the house as its first project. The property is now owned by the Hudson School District and leased to the Historical Society.

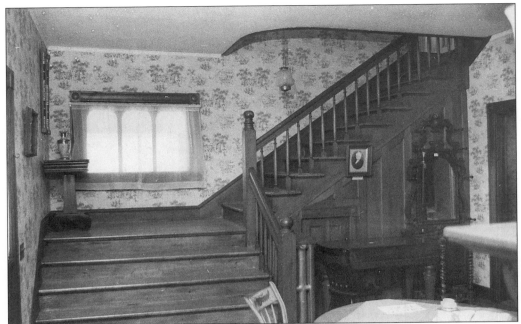

The grand staircase at Alvirne leads to several bedrooms, the tower room, and servants' quarters. The summer home was built with many windows and high ceilings to allow air to circulate throughout the building. The room at the top left of the stairs, now used by the Society to display children's items, was added onto the home after the original construction. This room contains carriage doors, which allowed travelers' trunks to be removed from the top of carriages and stored in this room.

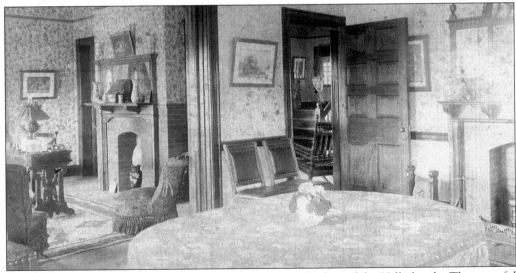

Alvirne Hills House dining room appeared this way in the days of the Hills family. The graceful foyer is visible through the door on the right, and the front parlor is shown through the entrance on the left. The solid wooden doors slide closed for privacy.

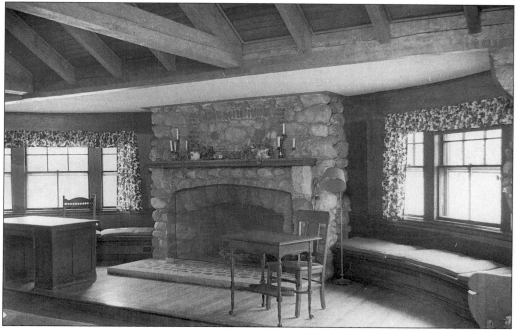

The meeting room at Alvirne was added in 1891, one year after the original house was completed. Mrs. Ida Virginia Hills designed the room as a library and worked closely with the architect to fulfill her wishes. The room later became the site of the first official classes of Alvirne High School in June of 1948. (This fulfilled the legal requirements of Dr. Hills's will and allowed the Town of Hudson to use the money bequeathed to build Alvirne High School.) The meeting room continues to be used by several organizations, including the Hudson Historical Society.

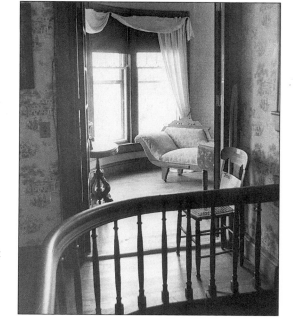

Often the favorite room of visitors, the tower, or "round" room, is also the smallest room in the house, but boasts one of the most glorious views through its windows. Mrs. Hills enjoyed painting, and perhaps this room was used as her artist's studio.

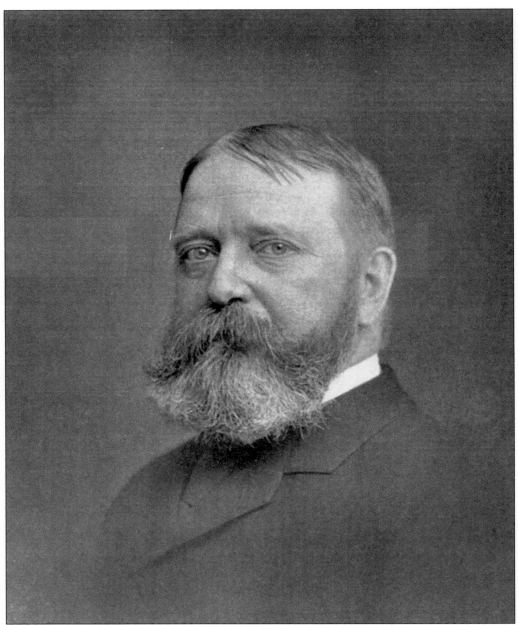

Dr. Alfred Kimball Hills was born in Hudson, New Hampshire, on October 20, 1840, to Alden and Nancy (Kimball) Hills. A direct descendant of the first Hills settlers of Hudson, he became a surgeon and established his practice in New York. Dr. Hills married his first wife Martha Simmons in 1865 but she died in 1885. Dr. Hills married his second wife Ida Virginia in 1887, bought 200 acres of land in Hudson from his father, and built Alvirne Hills House. Ida Virginia Hills passed away suddenly in 1908 at age 51, and Dr. Hills married his third wife, Jessie (Norwell) Hills, in 1910. Dr. Hills died in 1920 and bequeathed to the town money to build Alvirne High School and Vocational Center, built in 1950. Dr. Hills was interred in Hills Memorial Chapel.

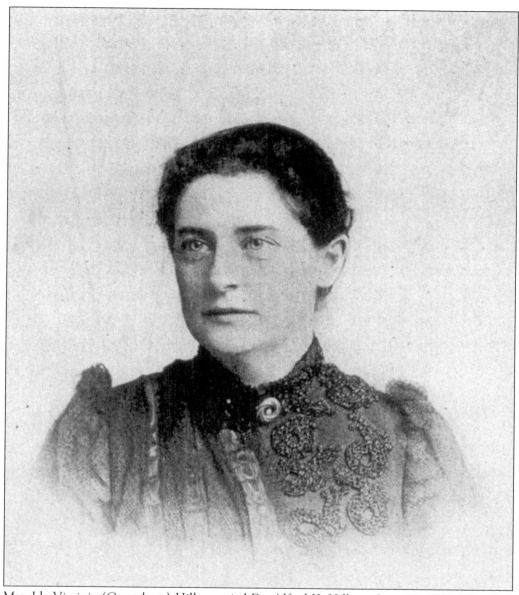

Mrs. Ida Virginia (Creutzborg) Hills married Dr. Alfred K. Hills on June 11, 1887. They had two children, yet neither survived beyond infancy. Mrs. Hills died suddenly in 1908 and was interred, along with her children, in the Hills Memorial Chapel. The Hills Memorial Library was built in her memory and dedicated on June 11, 1909, the anniversary of their wedding. In the Dedicatory Address, Arthur Stedman Hills said, "In the dedication of this library, we do reverence to a tender memory and acknowledge a kindly purpose. We also commemorate on this anniversary the consummation of a love . . . (which) found its deepest satisfaction in generous thought and deed. This memorial stands as a monument to the lofty endeavor of a life so full of sweetness and gentleness, that even those who knew it best scarcely realized its nobility, until it had faded and passed."

The Hills Memorial Library was built in 1909 in memory of Ida Virginia Creutzborg Hills through the generosity of her husband and her mother. Mrs. Hills shared with the town a great affection for reading and books. The Hills Memorial Library was dedicated on June 11, 1909, on what would have been Dr. and Mrs. Hills' 22nd wedding anniversary. The land on which the library was built was donated to the town of Hudson by Kimball Webster on what is now the corner of Ferry and Library Streets.

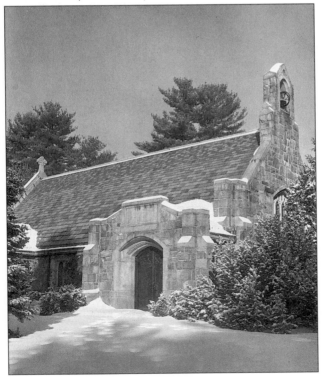

Alvirne Memorial Chapel was built by Dr. Alfred K. Hills in memory of his deceased second wife Ida Virginia Creutzborg Hills. The Chapel was consecrated in November 1909. The Chapel, built of granite with a slate roof trimmed in copper, was erected as a mausoleum but was also available as a mortuary chapel adjacent to the cemetery. In later years, it has become a popular location for local weddings, due to its picturesque setting. The beauty of the structure and the devotion of Dr. Hills to his wife certainly lend romance to nuptials.

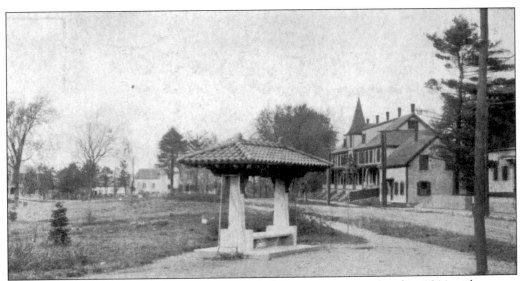

Library Park, also referred to as Hudson's Town Common, was completed in 1911 with money contributed by Dr. Alfred K. Hills and Mary Field Creutzborg, Ida Virginia's mother. This small parcel of land had been divided into 11 house lots, and one small house had actually been built before Dr. Hills offered to provide the money necessary to build a public park to preserve the land. The lone house was moved to a larger site close by. The trolley stop is shown in this photo.

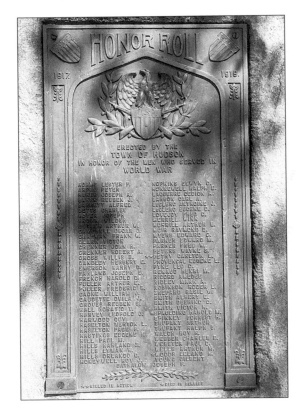

An Honor Roll was built by Hudson to respect those from the Town who served in World War I. This monument still stands in Library Park.

Dr. Hills married his third wife, Jessie Norwell Hills, in 1910. She survived Dr. Hills by 43 years and died in 1963. Since they had no children, there were no direct heirs to the estate, although there were many relatives. Mrs. Hills was one of the first members of the Alvirne Board of Trustees, and had actually hosted the first high school class of Alvirne in her own home, before the school was built in 1950. Mrs. Hills continued to summer at Alvirne Hills House until her death, when the home was closed. The house was vandalized and the Hudson School District considered razing the property, until the Hudson Historical Society formed to restore the beautiful Victorian.

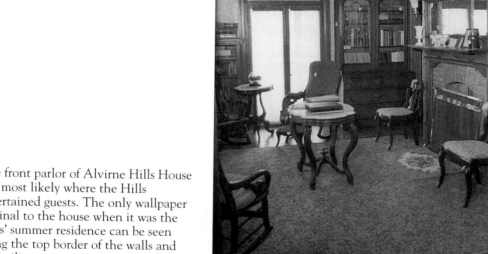

The front parlor of Alvirne Hills House was most likely where the Hills entertained guests. The only wallpaper original to the house when it was the Hills' summer residence can be seen along the top border of the walls and the ceiling.

Two
HUDSON CENTER

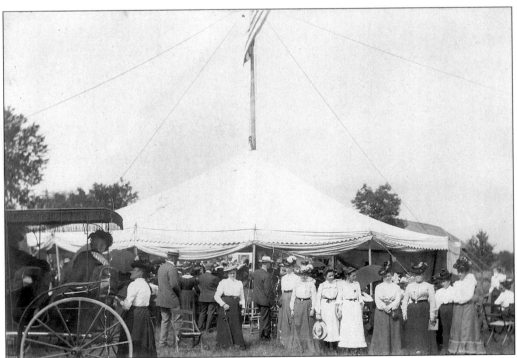

A group of celebrants poses for the camera at Hudson center, c. 1900. The State of New Hampshire's governor first declared a statewide celebration of Old Home Week in 1899, so this could possibly be such a gathering.

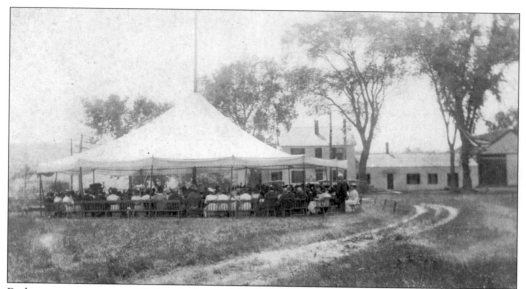

Perhaps a pre-cursor to Hudson's Annual Old Home Days event, residents sit under a tent at Hudson Center, now Route 111 by Greeley Street. The former home of Henry C. Brown is in the background, c. 1900.

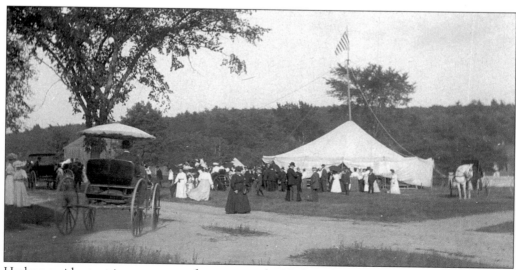

Hudson residents enjoy a summer afternoon on the Hudson Center Common, c. 1900.

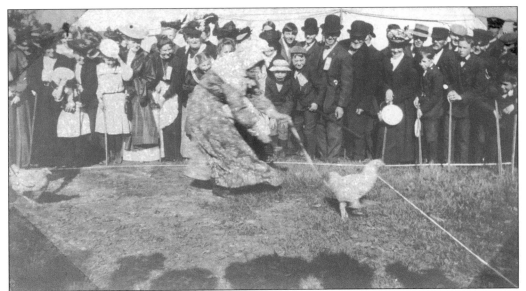

Hudson Center Common, now the area of Route 111 by Greeley Street, was the scene of many community activities, including the Hudson Grange Fair. A winner of the rooster race at the fair helps her bird over the finish line, to the delight of the onlookers, c. 1900.

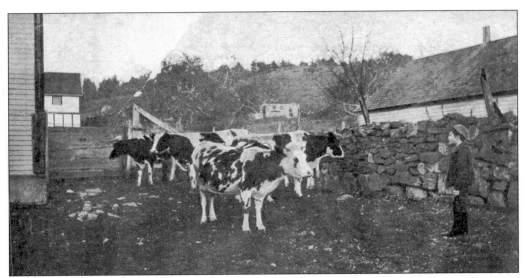

Pictured is the Haselton Farm in Hudson Center, c. 1900. The barn still stands on what once was Benson's Wild Animal Farm property, currently owned by the State of New Hampshire.

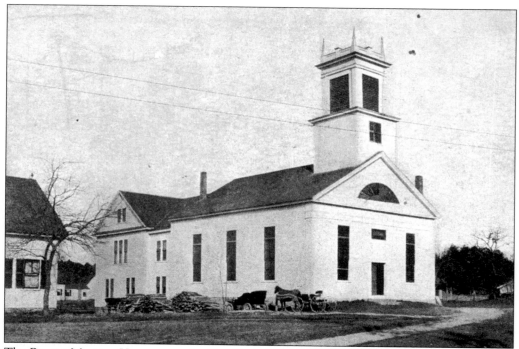

The Baptist Meeting House, now the First Baptist Church, was built in 1841 to give its church members their own place of worship. Prior to the construction of the church, the Baptists shared accommodations with the Presbyterians. This lovely church still stands at the corner of Central and Greeley Streets. This photograph dates to c. 1900.

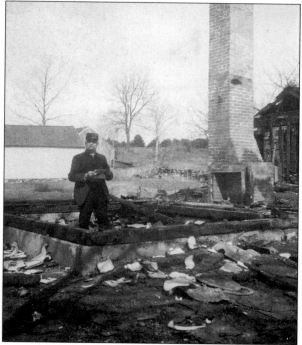

The Baptist Parsonage at Hudson Center, built in 1845, burned to the ground in the spring of 1909. Shown standing amid the ruins is Boston and Maine Railroad Station Agent Henry C. Brown. A new building was erected that year, and still stands on Central Street adjacent to the First Baptist Church.

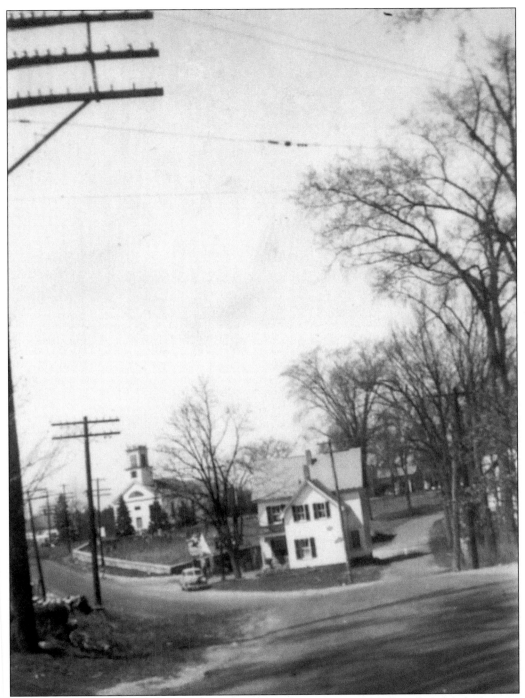

This 1946 view is taken from the Hudson Center School on Kimball Hill Road, looking at Moore's store. In the background is the First Baptist Church. Moore's store became and remained Thompson's Market, until a fire in the 1960s. Hudson Center Common is visible in front of the Baptist Church.

Hudson's Town Hall was once located in Hudson Center in the building now referred to as Wattanick Grange Hall. The Hall was built in 1857, and the Wattanick Grange began holding meetings in the building in 1921. The original organization split in two, and Hudson Grange number 11 held meetings near the Bridge area of town. The Town of Hudson sold the building to the Wattanick Grange for a small sum in 1963, and the Grange continues to use the building.

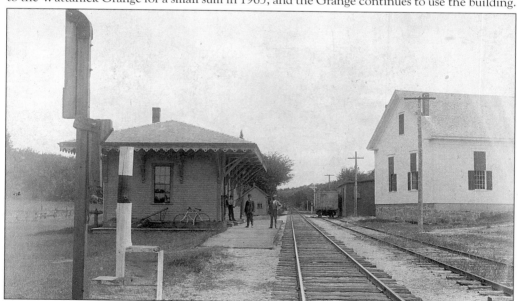

On the right of this June 1896 picture of Hudson Center Station is the back of the Grange Hall, which at the time was Hudson Town Hall. Henry C. Brown, the Station Agent, is also on the right. The train station was moved onto Benson Wild Animal Farm property many years later, where it still stands.

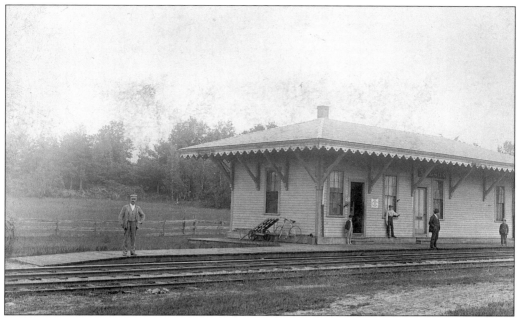

Hudson Center was the location of the Boston and Maine Railroad Station. Henry C. Brown, the Station Agent, is pictured on the left in this June 1896 photograph. Additionally, Brown was appointed the postmaster at Hudson Center in 1896 and remained in that position until the Hudson Center Post Office closed in 1910. Mr. Brown was appointed deputy sheriff for Hillsboro County in 1904, and held various town positions through the years including town moderator, selectman, and delegate to the General Court. Brown died in 1940 at the age of 81.

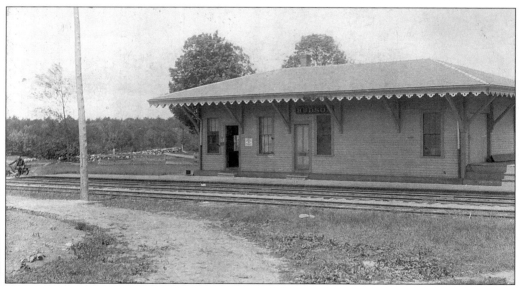

The Boston and Maine Railroad Station located at Hudson Center is pictured here in June 1896. The building is now on Kimball Hill Road.

This is a view of Hudson Center's railroad crossing looking down the tracks. The Boston and Maine Station is just out of the picture on the right.

The railroad paymaster, the time keeper, and the contractor pose in front of Henry Brown's home in Hudson Center in July 1902. The Hamblett home is just visible in the background, as are posts by the cemetery.

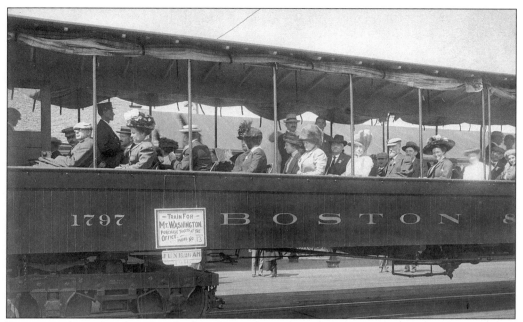

Passengers dressed in their Sunday best for a ride on the Boston and Maine Railroad on June 26, 1910. The placard indicated that they are bound for Mt. Washington. The couple above the *T* in "Boston" is Henry and Clara Brown, the Station Agent and his wife.

Formerly the First Congregational Church, the Hudson Grange was destroyed by fire to cover up a robbery in 1977. The building had been a meeting place for several town organizations as well as home to a restaurant and caterer.

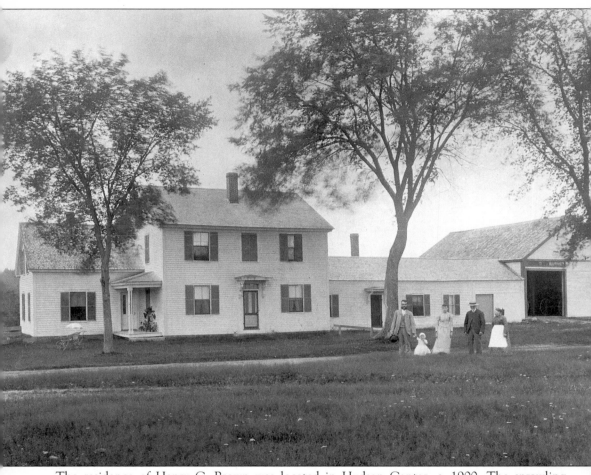

The residence of Henry C. Brown was located in Hudson Center, *c.* 1900. The sprawling farmhouse was located across Route 111 from the Baptist Church, but was torn down by the State of New Hampshire in the late 1990s. Pictured are, from left to right, as follows: Henry Brown, his daughter Ina Louise, his wife Clara Jane (Bryant) Brown, and his adoptive parents, John and Eliza Brown.

The First Congregational Church was built in 1842 on Central Street. After the merger of the First Congregational Church and the Methodist Episcopal Church, this building, known as the White Church, was sold to the Hudson Grange in 1933. The steeple was removed at this time. In 1977, the former church was destroyed by a fire. This image dates to c. 1900.

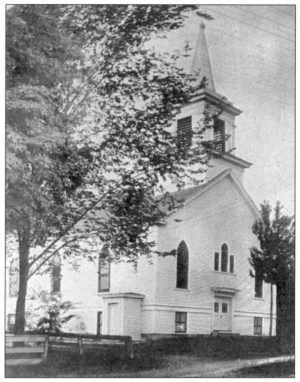

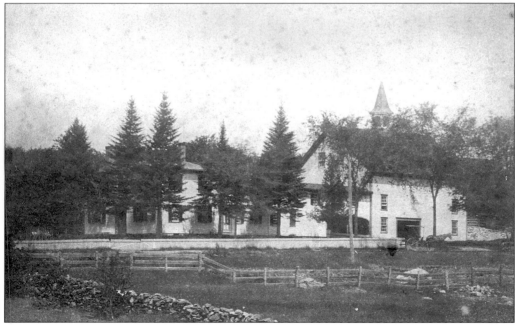

This lovely farmhouse was located in Hudson Center next to the home of Dr. H.O. Smith, and is believed to have been built by his father, Dr. D.O. Smith. The barn in this c. 1900 image was later taken down.

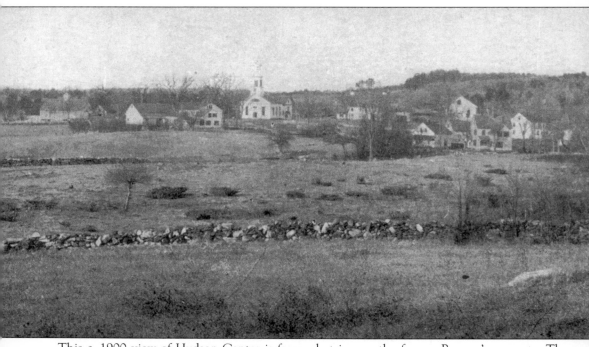

This *c*. 1900 view of Hudson Center is from what is now the former Benson's property. The Baptist Church is in the background, and just to the left is a view of Henry C. Brown's home from the rear.

Three

BENSON'S
WILD ANIMAL FARM

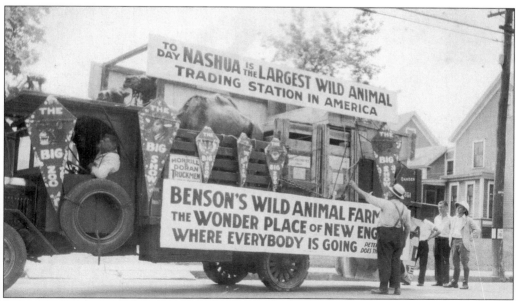

Benson's was where wild animals from all over the world came before they were sent to various zoos and circuses, or shipped to European countries. Often animals were brought to the old Union Station in Nashua on trucks similar to this one. John T. Benson used this opportunity to advertise his Wild Animal Farm.

In 1924, John T. Benson purchased land off Route 111 and Kimball Hill Road and started his Wild Animal Farm and training business. A famous wild animal salesman and trainer, Benson taught others how to handle all kinds of animals for circuses or Hollywood films. In 1926, Benson opened his farm to the public and expanded this popular tourist spot each year, until his death in 1943. Benson's was purchased by a group of Boston executives in 1944. In 1979, the Farm was sold again and became Playworld, then closed in 1987. The land is currently owned by the State of New Hampshire.

John T. Benson, Dr. H.O. Smith, and Frieda relax at Benson's Wild Animal Farm.

Many would take the train to Hudson Center and walk over to the entrance to Benson's on Kimball Hill Road. Benson's was a popular attraction for people from Massachusetts to Maine and beyond.

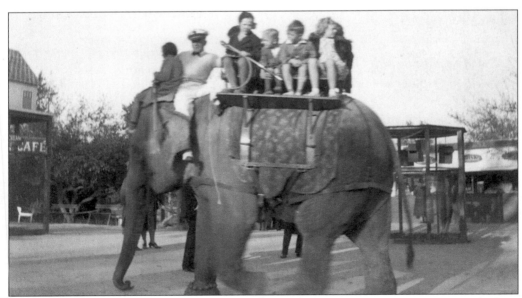

The elephant ride was a favorite attraction at Benson's. Riders would climb stairs to a platform and wait their turns, and the elephant saddles could seat people on either side.

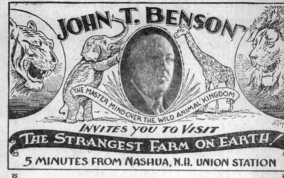
In the beginning, signs and advertisements like this early one mentioned Nashua, New Hampshire, until Benson's and the small town of Hudson, New Hampshire, became more well known. This ad mentions Hudson Center in parentheses, but highlights Nashua.

34

Some of the many attractions at Benson's Wild Animal Farm, called the Strangest Farm on Earth, included horses, monkeys, the art gallery, and the mummies. Groups could rent the farm for private functions. In later years, Benson's would remain open during the winter months for sledding, ice skating, sleigh rides, and evening light displays for the holidays.

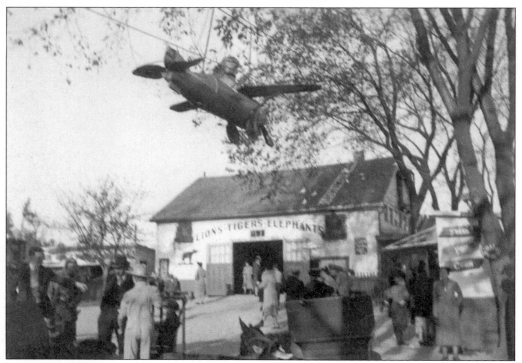

Another popular attraction was the airplane monkeys display. The monkeys would pull themselves in airplanes along a wire to reach their destination, peanuts, at either end.

After John T. Benson's death in 1943, a group of men involved with the Boston Garden bought Benson's Wild Animal Farm. The Farm was closed to the public during World War II, but reopened in 1945 with the same high standards that made Benson's so famous. One of the buyers was Raymond Lapham, shown here in 1948.

Vera Lovejoy became the manager of
Benson's in the late 1940s.

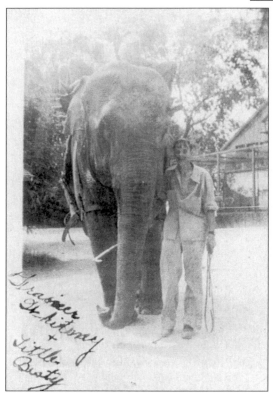

Trainer Llewellyn Whitney of Nashua and
"Little" Betsy are shown here in 1948.

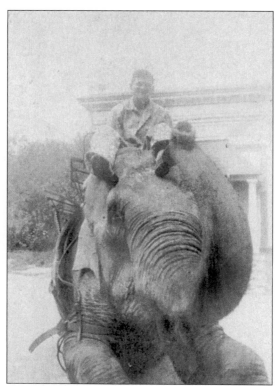

Wild animal trainer Paul Lemery rides Betsy in 1948. Lemery grew up in Nashua and made his start at Benson's, where he worked for over a decade starting at age ten. While working with his nationally known bear act in Libertyville, Illinois, in 1956, Lemery was attacked and killed by one of the bears. He was only 28 years old.

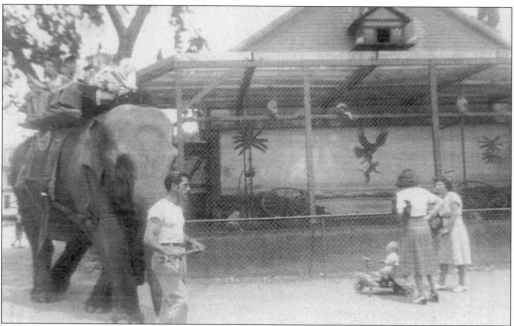

Rudy Roy guides Betsy the elephant past the monkey cages. The elephant saddle had seating on either side. Betsy was a favorite of both young and old for many years and had been trained originally by John Benson himself. Betsy died in 1971 and was buried on the Benson's property.

The elephants are shown arriving at Benson's from the Nashua train station in 1948. They were escorted on foot to their new home at Benson's. This must have been quite a spectacle for local traffic, although Hudson residents became used to seeing an occasional stray animal.

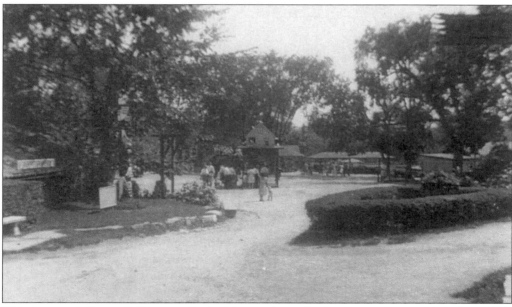

This image of Benson's fairgrounds, looking in from the front gates, was captured c. 1948. Benson's was open year-round; activities in winter included skating and sleigh rides.

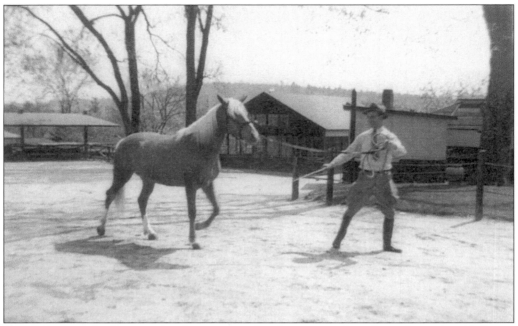

Fred Pitkin was the horse and mule trainer, and is shown at work with a palomino in 1948.

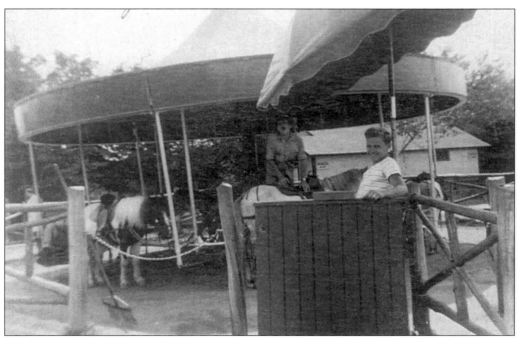

Normand Vallaincourt ran the pony-go-round—a carousel with real horses—c. 1948.

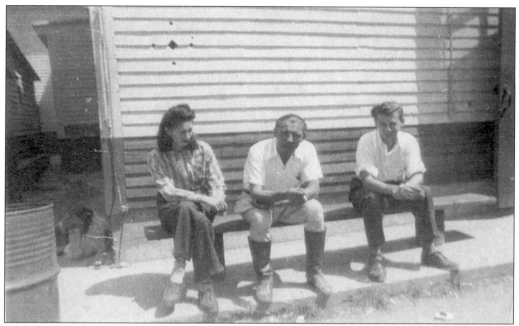

Zeakolen Walch, her husband Joe Walch, and a friend take a break from training the animals at Benson's, c. 1948.

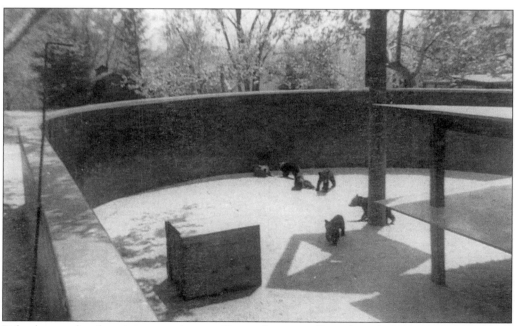

Baby bear cubs, favorite attractions at Benson's, were allowed to frolic in a giant cement playpen, c. 1948.

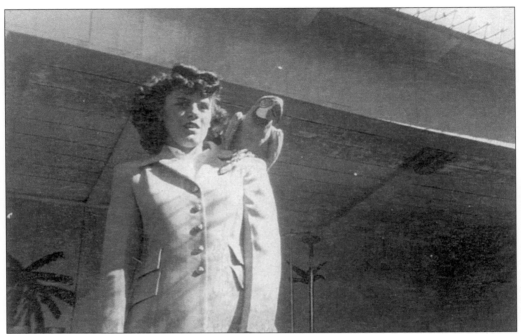

Doris Archambault was the bird trainer at Benson's, *c.* 1948. At the front entrance to the farm, birds would perch in the trees and in bird coops, but they would all come down upon command when someone whistled for them, which delighted the public.

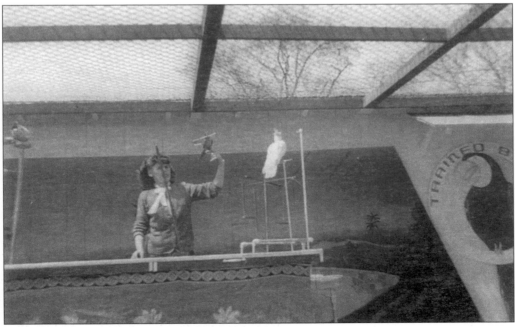

The darker bird in Doris Archambault's bird act was named King, *c.* 1948.

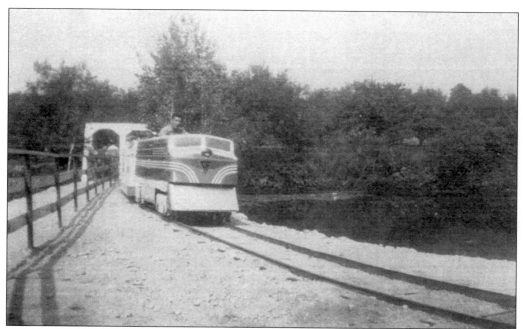

Engineer Harvey Dumas drove the miniature railroad around the grounds of Benson's. "The Jungle Flyer" brought riders around the park to see the sights, including swans in the pond, deer, mountain lions, and other animals living in their natural environments.

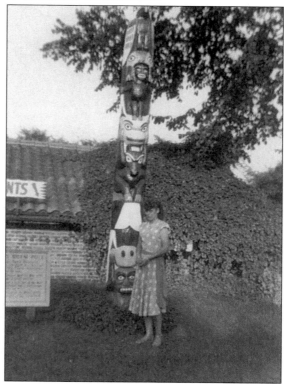

Bird trainer Doris Archambault poses in front of the totem pole by the souvenir and refreshment stand, c. 1948.

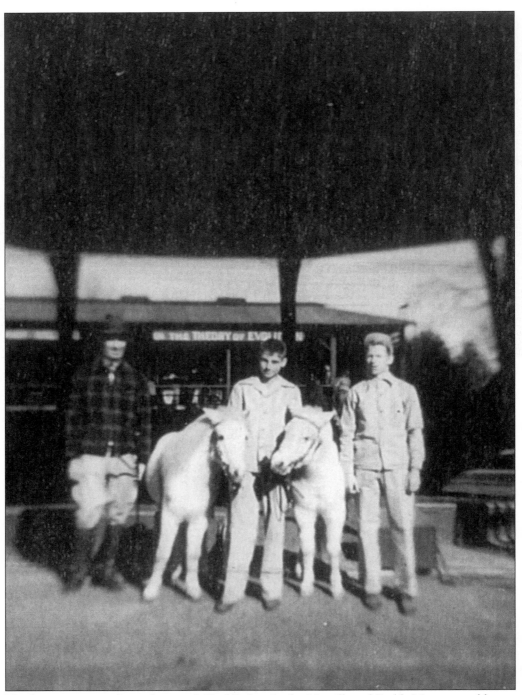

The boxing ponies, shown here with Fred Pitkin, Leslie Morrill, and Buddy Moore, would wear actual boxing gloves and "duke it out" for the audience. There was also a counting horse that would solve math problems by giving his answer in hoof stomps. He wasn't often wrong.

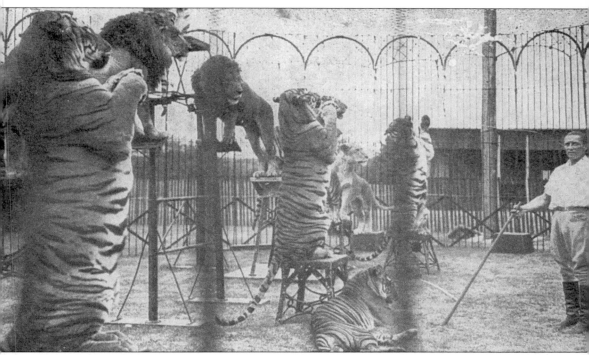

Joe Walch worked as a trainer at Benson's for many years. He was famous for his act that included many lions and tigers in the cage at one time. He was always willing to try more daring and dangerous stunts to thrill the crowd. His wife, Zeakolen, also worked at Benson's, c. 1948.

Ma and I are at the Benson Wild Animal Farm, Hudson, Near Nashua, N. H.

The Rheasus monkeys' cage was always a favorite stop.

Bobo the baboon and Junior the trained chimpanzee were popular attractions at Benson's in 1948.

The polar bears were kept cool with a continuous supply of ice chips in their water dishes. Hot Hudson summers were not the polar bears' favorite time of year.

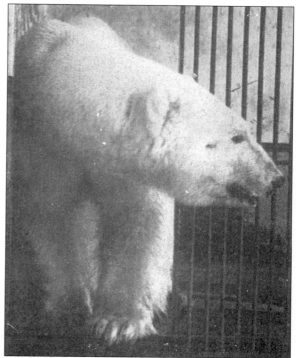

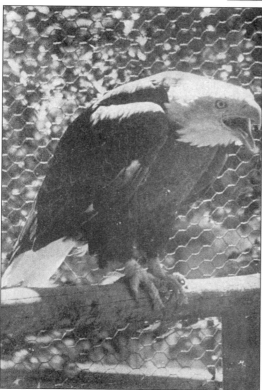

All kinds of exotic creatures could be seen at "The Strangest Farm on Earth," including an American Bald Eagle, c. 1948.

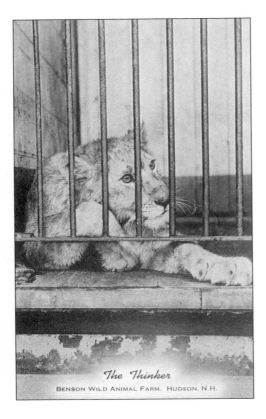

A postcard depicts one of the animals at Benson's. "The Thinker" was a perfect choice for the caption.

The Thinker
BENSON WILD ANIMAL FARM. HUDSON, N.H.

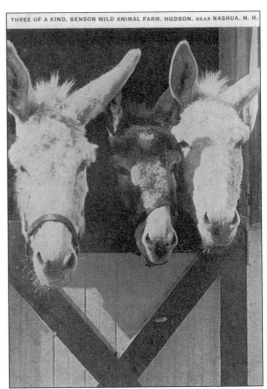

THREE OF A KIND, BENSON WILD ANIMAL FARM, HUDSON, NEAR NASHUA, N. H.

The donkeys were actually Baluchi Wild Asses imported from Baluchistan, *c.* 1948.

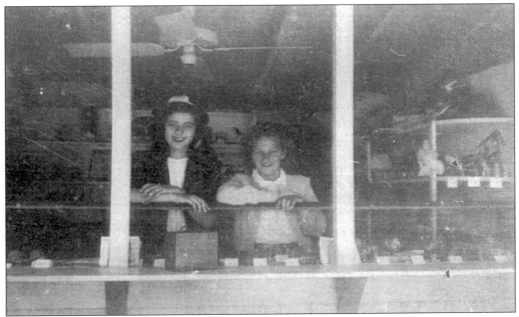

Florence Relations and Edna Annis pause while running souvenir booth number one in 1948.

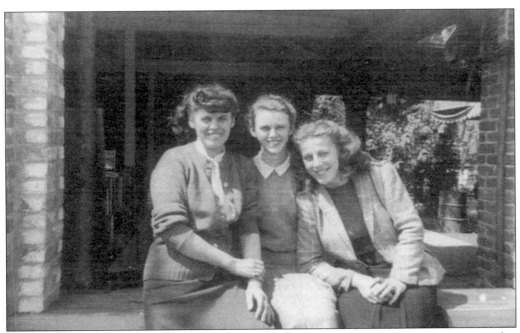

Doris Archambault, Pauline Smith, and Rachel Zebenis, steady help at Benson's, pose in this spring, 1948 photograph.

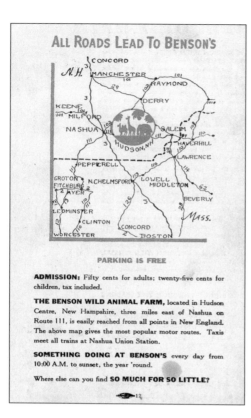

All Roads led to Benson's, and this 1940s pamphlet showed this was true. Every day was circus day, according to the brochure, which told guests that, "In summer bring your picnic basket, in winter bring your skates, but always bring your camera and your walking shoes and don't forget your biggest smiles!"

Another brochure described Benson's as fun for children of all ages, open from ten in the morning until sunset. Admission was only 50¢ for adults and 25¢ for children.

Four

THE BRIDGE SECTION

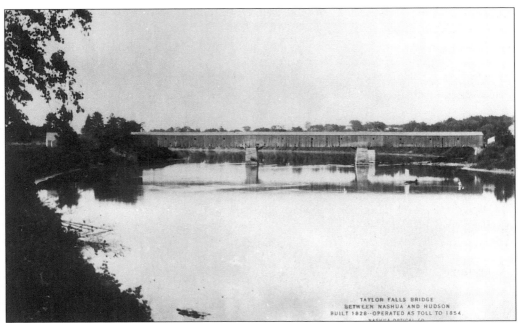

TAYLOR FALLS BRIDGE
BETWEEN NASHUA AND HUDSON
BUILT 1828--OPERATED AS TOLL TO 1854.

The original Taylor Falls Bridge was built in 1827 to link Hudson and Nashua, New Hampshire. It opened as a toll bridge across the Merrimack River. Before its construction, the closest bridges across the river were in either Lowell, Massachusetts, or Manchester, New Hampshire. The bridge was labeled unsafe in 1881 and a new bridge was built.

The original Taylor Falls Bridge was built of pine with a shingled roof and cost approximately $12,000 to erect.

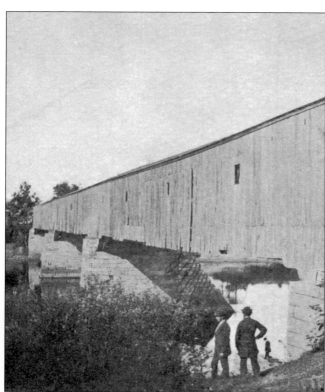

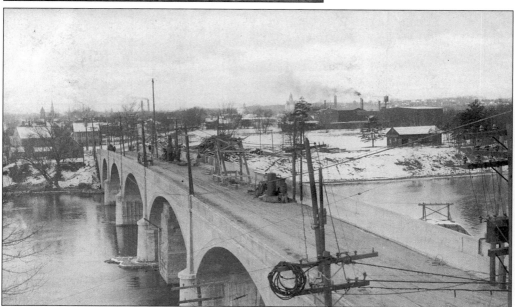

A concrete bridge to Nashua was built in 1912 to accommodate the heavy electric trolley cars. Although the builders were ordered to provide restricted access across the river during construction, prior to its completion passengers going to and from Nashua on trolleys had to walk over the bridge.

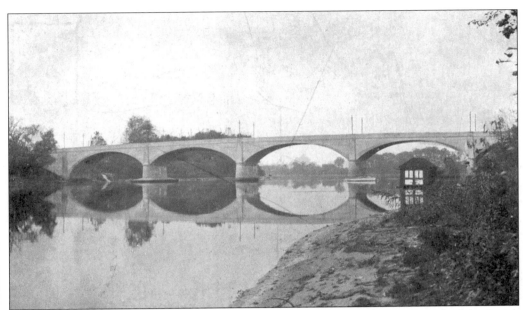

The Cement Bridge connected Nashua and Hudson, New Hampshire, across the Merrimack River.

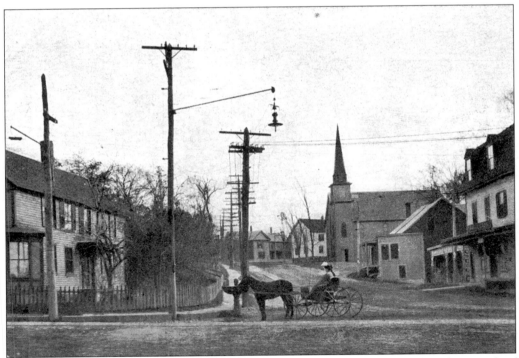

The trolley lines are visible and the Baker Brothers Store is on the right of this photograph of Post Office Square, c. 1900s. The Methodist Episcopal Church is in the background.

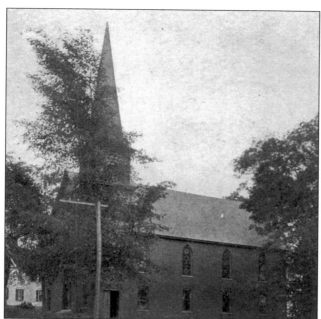

The Methodist Episcopal Church, known as the Brick Church, was built in 1880 near the bridge to Nashua. It is now known as the Community Church of Hudson.

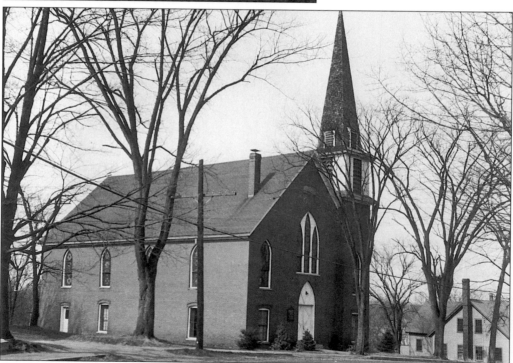

The Community Church, a non-denominational church located on Central Street by the bridge to Nashua, was formed in 1933 by the union of the First Congregational Church and the Methodist Episcopal Church. The former Methodist Episcopal Church, known as the Brick Church, became the meeting place and the Congregational Church was sold to Hudson Grange number 11. This picture was taken in 1946.

54

On October 22, 1950, the Hudson Community Church dedicated its new organ and Sanctuary. Many volunteered their talents, including Donald Spalding, who constructed the Chancel, rail, lectern, and pulpit. In addition, Frank Nutting Jr., John Burnham, and Raymond Browne donated all the electrical work, wiring, and the installation of fixtures. The Chairman of the Organ Committee was Grant Jasper, and the Chairman of the Renovation Committee was Charles Holt. Several former ministers of the Church participated in the Service.

Service of Dedication

for the

Organ and Sanctuary

The Community Church

of

Hudson, New Hampshire

OCTOBER 22, 1950

7:30 P. M.

JAMES A. WOOD, *Guest Organist*

ARNOLD W. TOZER, *Minister* MARION JOY, *Organist*

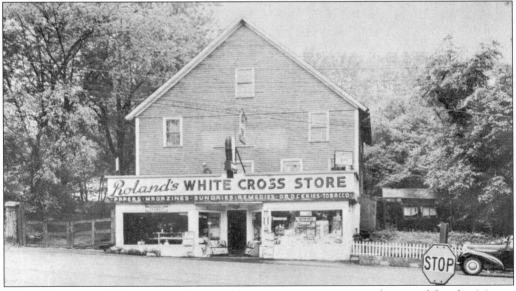

Roland Levesque's White Cross Store on Ferry Street was previously owned by the Martin sisters. There was a small passage way connecting their store to their home on Central Street, and they would know they had customers when they heard the bell that was connected to the door. They then would return to the store to wait on their customers.

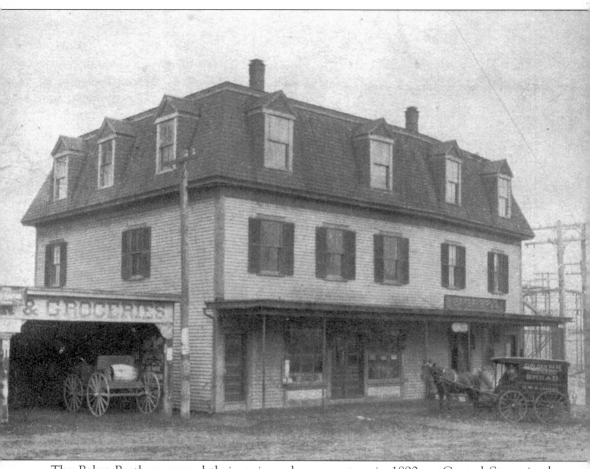

The Baker Brothers opened their grain and grocery store in 1890 on Central Street in the Bridge area of Hudson. Greeley Library was located on the top floor from 1895 to 1909, when the Hills Memorial Library was built. Apartments on the second floor were available for rent. The building was torn down in the late 1960s.

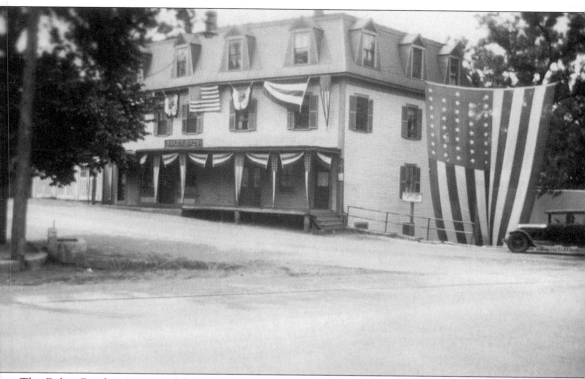

The Baker Brothers' store celebrated Hudson's Bicentennial in 1933. The large flag on display is now part of the Hudson Historical Society's collection.

This is a *c.* 1920s view of Webster Street looking north, with Ferry Street on the right. The old jail is the small building on the left.

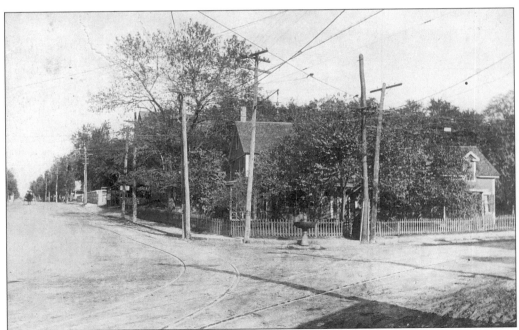

This was the view of Hudson after coming over the bridge from Nashua, *c.* 1920s. On the left is Ferry Street, and on the right is Central Street. The house shown no longer exists.

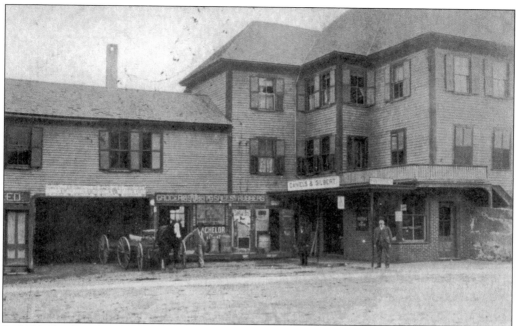

In 1853, the location of the Hudson Post Office was moved from Hudson Center to the Greeley Store building. This building also became the home of the Daniels and Gilbert grain and grocery store. Charles Daniels served as the postmaster from 1903 to 1913, as well as tended to his grocery store.

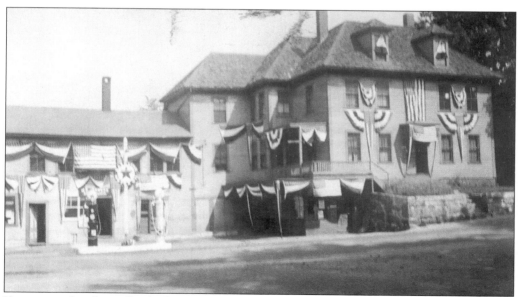

Known as the Connell Block at the Bridge, these buildings are dressed to commemorate Hudson's Bicentennial in 1933. Hudson held a huge celebration in June of that year to commemorate its 200th anniversary since it began as Nottingham, Massachusetts.

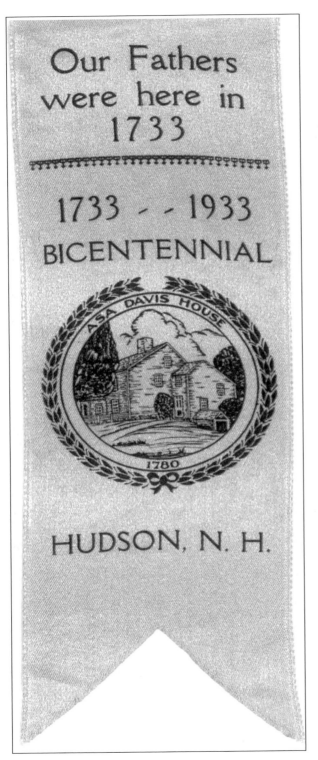

Our Fathers were here in 1733

1733 - - 1933

BICENTENNIAL

ASA DAVIS HOUSE

1780

HUDSON, N. H.

Invitations were sent out to as many descendants of original Hudson settlers as could be found. Those who did return for the celebration were given commemorative ribbons to wear, stating, "Our Fathers were here in 1733." The Asa Davis House, built in 1780, was depicted on the front of the ribbon. This home was located on Bush Hill Road and later became the Morrison home. Asa Davis was a lawyer, Town of Hudson Selectman off and on from 1780 to 1808, and a Representative to the General Court from 1777 to 1808. According to Webster's History of Hudson, there was a swamp near the Davis house called "moose swamp," called such because it was there that Asa Davis killed the last known moose in Hudson.

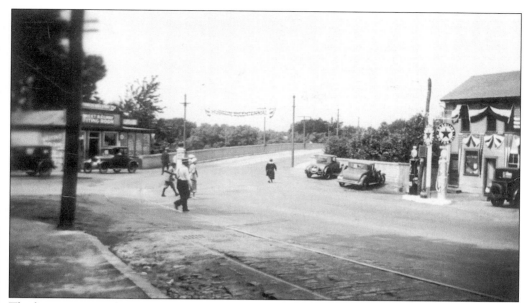

The banner across the poles by the bridge reads, " Hudson Bicentennial," which was celebrated during three days of activities in June 1933. This picture shows the Taylor Falls Bridge from Ferry Street. Trolley tracks are visible, as is the Railway Waiting Room.

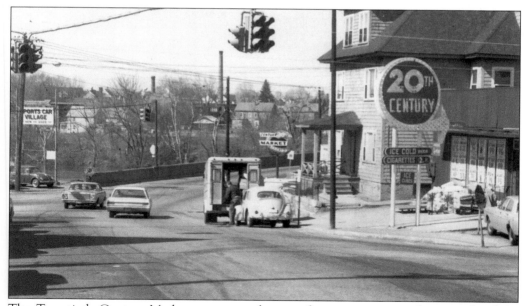

The Twentieth Century Market was a popular stop for many years until it was slated for demolition to make way for a new bridge to Nashua. However, it was destroyed by fire in 1969 before it could be torn down.

IMPORTANT NOTICE

DUE TO THE FLOOD The Public Service Company of New Hampshire has been obliged to stop gas service in the City of Nashua and Town of Hudson. The gas will be turned on as soon as conditions make it safe to do so.

MAKE A PERSONAL EXAMINATION and see that EVERY BURNER COCK IS CLOSED and KEPT CLOSED UNTIL THE GAS IS TURNED ON.

Residents were without electricity and gas service for at least one week during the Flood of 1936, and Hudson was at a standstill. Basements were flooded, floors and furniture ruined, and homes had to be inspected before those who had been evacuated were allowed to return.

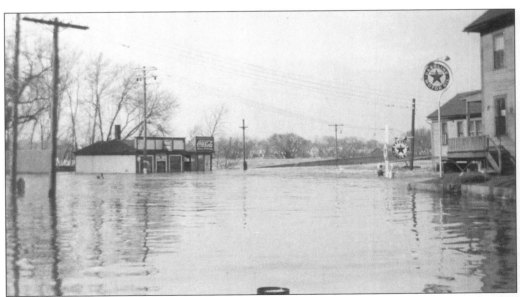

A photograph of Taylor Falls Bridge was taken during the Flood of March 1936. Many families living near the Merrimack River were evacuated. Heavy snow, high temperatures, and then heavy rain contributed to the disaster, which effected all of the New England area.

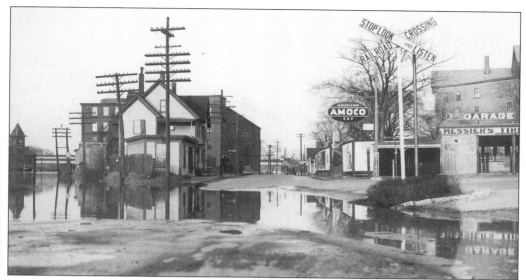

Here, water begins to recede from East Hollis Street in neighboring Nashua in 1936. The Old Union Station is in the background on the left, and this view is looking towards Hudson. The garage still exists today.

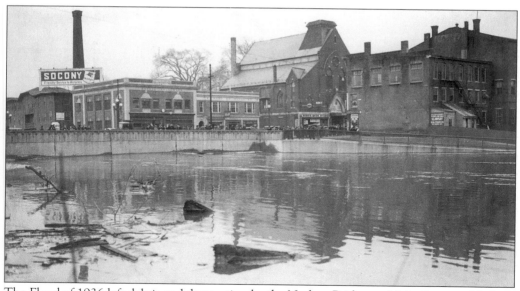

The Flood of 1936 left debris and destruction by the Nashua Bridge on Main Street in Nashua. The Old Park Theater, once a church, is shown, along with the *Nashua Telegraph* Newspaper Building and the Sargent Building.

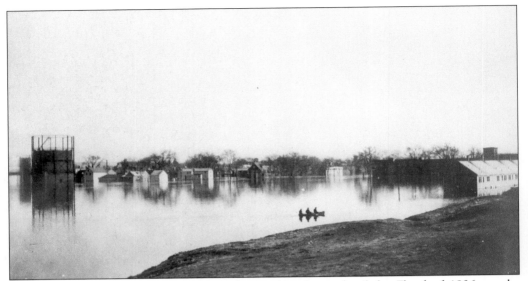

The only way to travel near the river during the aftermath of the Flood of 1936 was by boat. With the Gas Works on the left, three people boat across the Merrimack River in Nashua, New Hampshire. The raging flood waters destroyed houses, uprooted trees, and floated debris for miles.

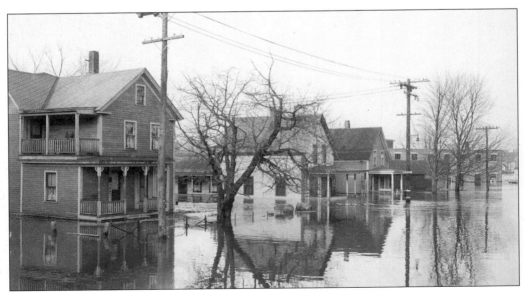

Crown Street in Nashua is shown at the height of the flood in 1936.

Five

STUDENTS AND
SCHOOLS

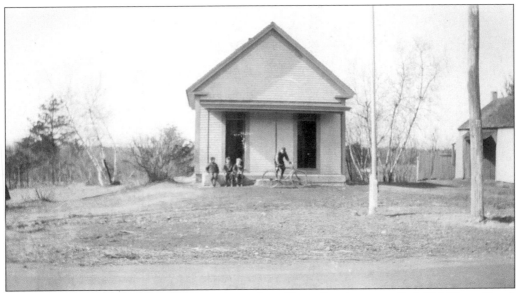

This is the Number Nine schoolhouse located on Derry Road, now called Old Derry Road, pictured in the 1920s. Built in 1886, it closed at the end of the school year in 1932, the last one-room schoolhouse to be used in the Town of Hudson. It is also the only one-room schoolhouse to remain in its original condition. The building was purchased by Grant Jasper in 1938 and is owned by the Jasper family.

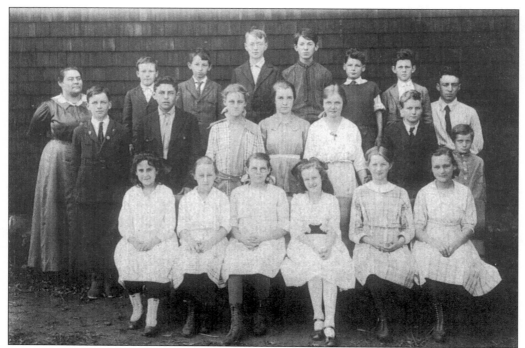

School students pose for a class photo with their teacher in this *c.* 1915 picture. Although no records were found to identify the students, this is one of the clearest pictures the Society has of local school children in varying styles of dress.

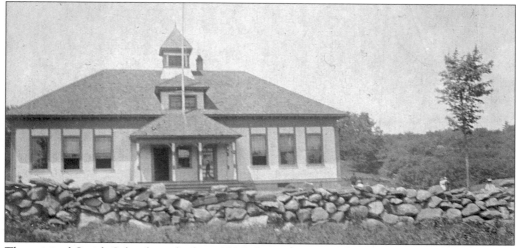

The original Smith School was built in 1896, the same year as the Webster School, in order to accommodate children near Hudson Center. It was named after Dr. David O. Smith and built on land he donated to the town. After the Smith and Webster Schools were built, the multiples school districts were consolidated to form one school district, and most children in Hudson attended one of these schools. However, schoolhouses numbers One and Nine remained open until the 1930s. The Smith School was destroyed by fire in 1907. In 1908, a new school was built on Kimball Hill Road and was named the Hudson Center School. This image dates to *c.* 1896.

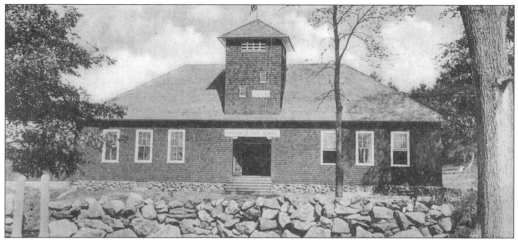

The Hudson Center School was built in 1908 on Kimball Hill Road on land donated by John Wentworth and Arvilla and Souvina Hamblet. The school was erected in the part of town known as Hudson Center, and replaced the Smith School, which burned down in 1907. The original bell from the Hudson Center School is now part of the Hudson Historical Society's collection. In 1913, children from Windham, New Hampshire, traveled by train to Hudson Center to attend the Hudson Center School. The town of Windham paid their tuition, which cost less than hiring their own teacher.

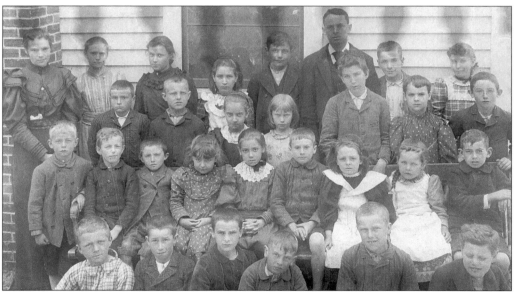

Students of the Number Five School, called the Hudson Center District School, pictured in this c. 1880s photograph are, from left to right, as follows: (front row) Elmer Smith, Howard Andrews, Dan Wentworth, Poddy Thorn, ? McCoy, and Ernest Parker; (second row) Harry Clement, Arthur Smith, Johnny Downey, Jessie Clement, Chester Walsh, Cora Smith, and Leander Buttrick; (third row) Perley Walsh, Dan McCoy, Laura Melvin, Ethel Robinson, Albert Thorne, Minnie Wentworth, and Jerry Sullivan; (fourth row) Helen Jacques (teacher), Marion Walsh, Lillian Parker, Bertha Thorne, George Parker, John Wentworth, unknown boy, and Mary Clement.

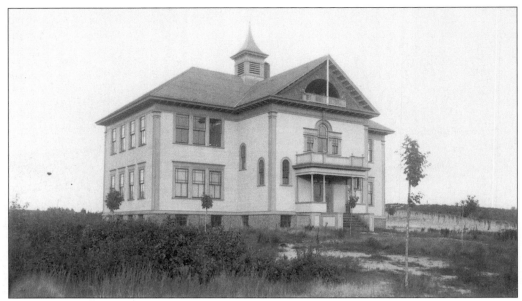

The Webster School was built in 1896 on Sanders Street, now known as Library Street, and named in honor of Kimball Webster. Webster was a prominent member of the community who would later publish the extensive book, *Webster's History of Hudson, New Hampshire, 1673–1912* in 1913. Mr. Webster was born in 1828 and died in Hudson in 1916. The Webster School is now the School Administrative Offices building. This image dates to *c.* 1896.

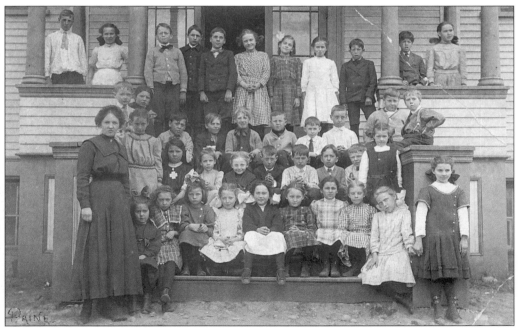

These are the third and fourth graders of the Webster School, *c.* 1900. The teacher on the left was Louise Morrison.

Students of the Webster School in 1914 are, from left to right, the following: (front row) Everett LaFrance, Vanita Pollard, Zoula Ferryall, Eleanor Youlden, Vera Fish, Genevieve Campbell, Ralph Melendy, and Albert Fisher; (second row) Velma Campbell, Ruth Steele, Lillian Oliver, Almeda Bassett, and Edna Rattee; (third row) Lilla Wilshire, Hazel Jewel, Rena Trufant, Lillian Trufant, and Clara Marquis; (fourth row) Wilson Clyde, Harry Sanders, Percy Rounsevelle, Harry LaPorter, Walter Lear, Chester Merrill, Martin Downey, Donald Merrill, Robert Andrews, Edward Marshall, and Harold Marshall.

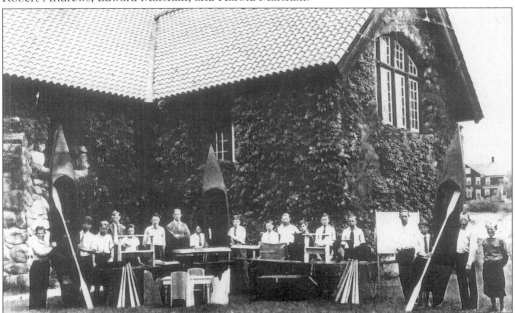

Mr. Richard Bridges's class of seventh graders from the Webster School pose with the various baseball bats, kayaks, tables, chairs, and bookcases they built. This 1934 photo was taken in front of the Hills Memorial Library, which was built next to the school.

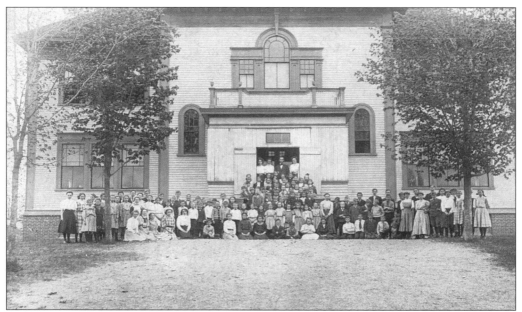

All eighth grades are shown in this 1910 picture taken in front of the Webster School.

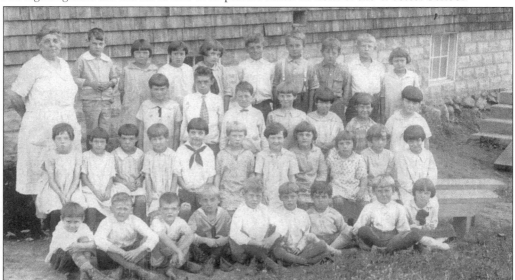

These are Hudson Center School children, grades one through four, in 1927. The teacher was Miss Lilla Deering. Included are, from left to right, as follows: (bottom row) Robert McCoy, Albert Zinkawick, one unidentified student, Jim Hook, George Benson, Lawrence Steele, Francis Knights, one unidentified student, and Louise Hammond; (second row) Bertha Newman, one unidentified student, Lorraine Knights, Sarah Steele, Jane Steele, Doris Moore, one unidentified student, Bertha Tessier, one unidentified student, Gloria Smith, and one unidentified student; (third row) Mildred McCoy, Jack Baxter, one unidentified student, Helen Smith, Marion Eaton, Ruth Eaton, and Margaret Hazelton; (top row) Howard Lamson, Yvonne Tessier, Alice Martin, Thelma Bagley, Mike Woolen, Donald Bagley, Clayton Smith, Robert Moore, and Lillian Baxter.

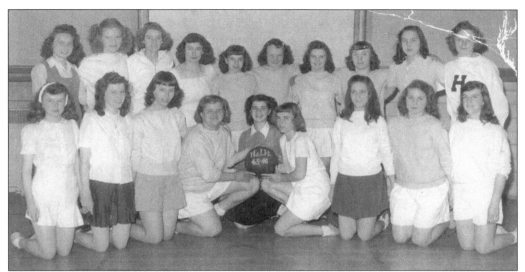

The 1946 girls' basketball team at H.O. Smith School, Hudson's Junior High, included, from left to right, the following: (front row) Mary Riley, Pauline Jean, Charlotte Cooke, Theresa Levesque, Vicki Simo, Marjorie Burnham, Margaret Hardy, Theresa Turmel, and Alice Howard; (second row) Ruth Waiswilos, Shirley Estes, Bev Tetler, one unidentified player, Joan Kalil, Patty French, Barbara Campbell, June Dupont, Joanne Lemire, and Nancy Allen.

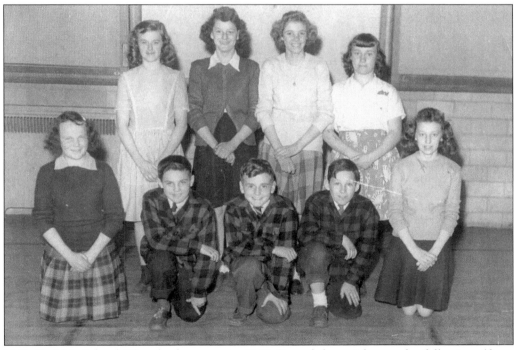

H.O. Smith's School Cheerleaders pose in 1948. From left to right are the following: (front row) Pat French, Paul Galipeau, George Paul, Oswald Boilard, and Edith Baker; (back row) Alfreda Pinette, Jackie Jean, Bev Tetler, and June Dupont.

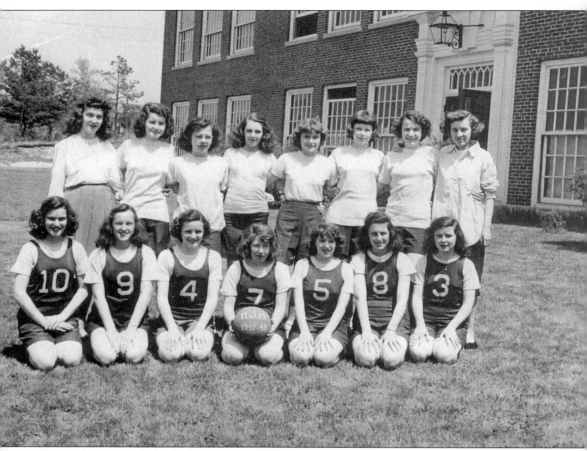

The ninth grade girls' basketball team at H.O. Smith Junior High in 1948 included, from left to right, the following: (front row) Jewel Austin, Mildred Poliquin, Theresa Gamache, Barbara Holt, Joan Kalil, Norma Bardsley, and Bea Moulton; (back row) Coach Dorothy Eaton, Deanne Baker, Esther Ruiter, Anne Marshall, Georgette Leprise, Jean Cady, Arline Mason, and Jeanne Ellis. On game day, each girl wore her own T-shirt to the games, and when one player went in for another player, they first had to exchange playing jerseys, as there weren't enough uniforms for all of them. They won every game except one in 1948.

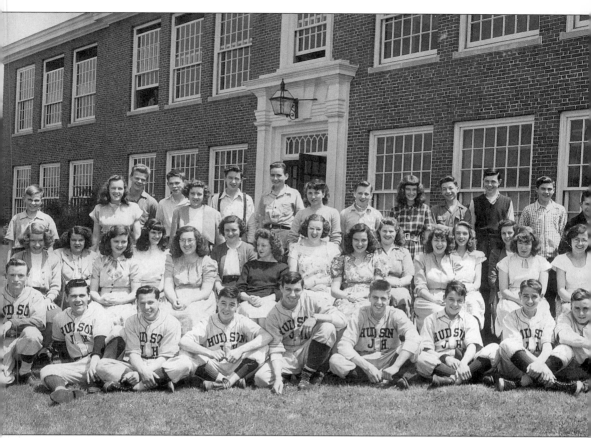

This 1948 photo depicts the ninth grade class at Dr. H.O. Smith School, which would go on to become the first graduating class at Alvirne High School on 1951. Included are, from left to right, as follows: (front row) Ralph Lones, George Forrence, Arthur Brown, Norman Boucher, Donald Whitten, John Simo, Jerry Boilard, Louis Carter, and George Paul; (middle row) Audrey Oliver, Barbara Rock, Bea Moulton, Adeline Desrosier, Marie Farley, Theresa Gamache, Fay Thomas, Elaine Page, Jewel Ann Austin, Arlene Gagnon, Joan Kalil, Sally Fairbanks, Norma Bardsley, Barbara Holt, and Esther Ruiter; (back row) George Abbott, Mildred Poliquin, Bill Baker, Jerry Cady, Jeanne Ellis, James Bardsley, Paul Phalen, Claire Declos, Clyde Smith, Pat Riley, Robert Constant, James Allard, Paul Galipeau, and Victor Beauregard.

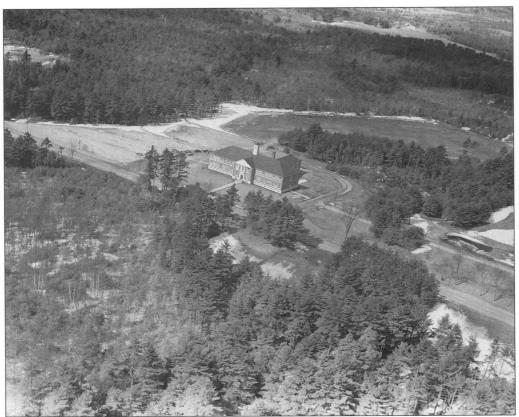

An aerial view of Alvirne High School was taken c. 1950, shortly after construction was completed but before the barn, ballfields, and parking lots were built. In 1960, eight rooms and the vocational/agricultural building were added, followed by 16 more rooms in 1965.

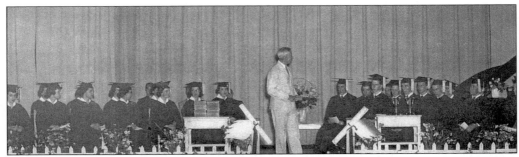

The 25 students of the first graduating class of Alvirne High School received their diplomas at its graduation ceremony on June 13, 1951.

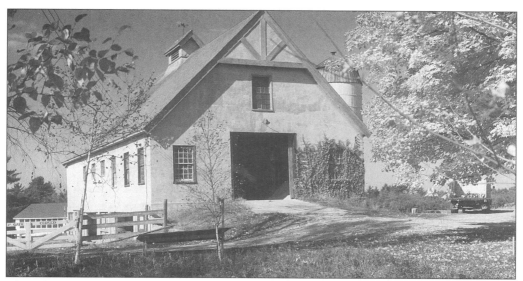

The silo was built in front of the Alvirne High School Barn in 1956, the same year this photograph was taken. The barn housed cows, chickens, hay, and equipment, and students learned by working with the animals and the land. The barn was destroyed by fire in 1992, but was rebuilt to allow the excellent agricultural science program to continue.

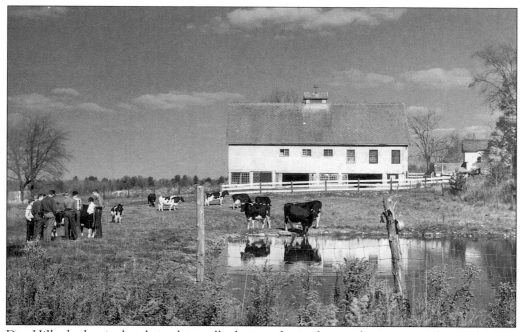

Dr. Hills had stipulated in his will that students from other towns who wished to study agriculture at Alvirne School Farm could do so. Students came from many neighboring towns including Nashua, Litchfield, Windham, Pelham, and Londonderry. This image dates to c. 1956.

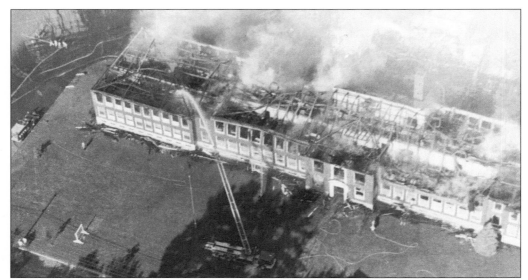

One of the most devastating fires to affect the entire community occurred on Sunday, September 8, 1974. Two days after school had reopened for the fall, Alvirne High School was destroyed by what fire officials later called arson. Many town residents, students, and teachers worked long hours in the next weeks to salvage what they could. An empty school building in Nashua was rented, and double sessions began at Memorial School to accommodate the 1,200 displaced students.

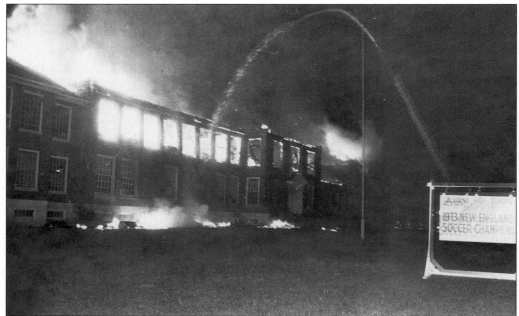

The fire that consumed Alvirne High School began in the pre-dawn hours. The daylight hours confirmed the loss of Alvirne High School. Mutual aid from other communities helped fight the blaze, but the school could not be saved. The original architects of the building were hired to help with reconstruction. On September 9, 1975, Alvirne High School Students returned to the re-built school.

Six

FIRE AND POLICE

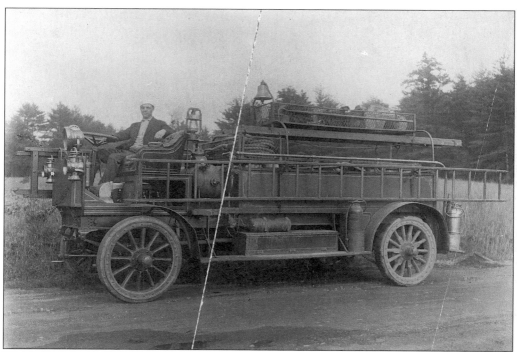

Walter Harwood poses on board the Kelly Springfield Fire Truck. The truck was purchased in 1913 for $1,030 raised by the firefighters. It is possible that this was the first motorized fire truck used in New Hampshire.

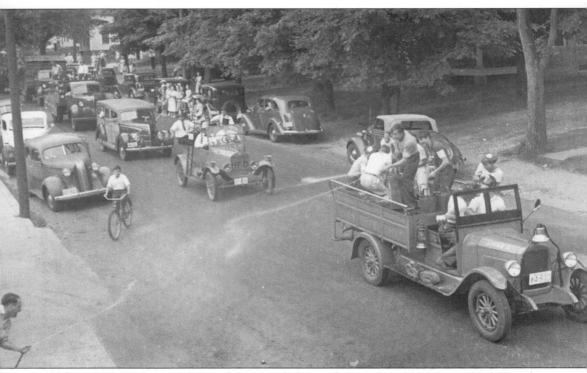

Hudson Fire Department's Squad A preceded Squad C in this Old Home Week Parade in Nashua. Although the Department retired Squad A from active duty, it is still owned by the Department and participates in local parades.

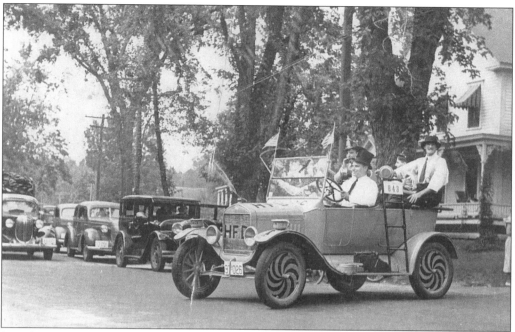

Squad C is shown from a different angle in the Nashua Old Home Week parade.

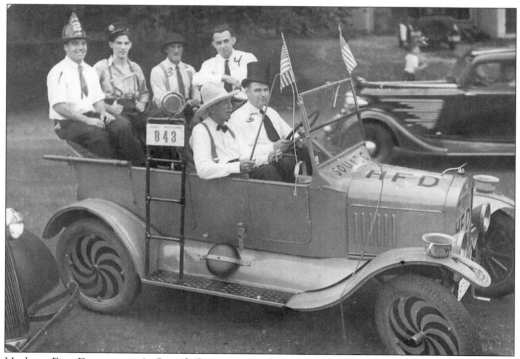

Hudson Fire Department's Squad C participated in an Old Home Week parade in Nashua. Pictured are, from left to right, the following: Arthur Shepherd, one unidentified man, Bill Egly, Richard Dane, Henry Shepherd, and Rob Connell.

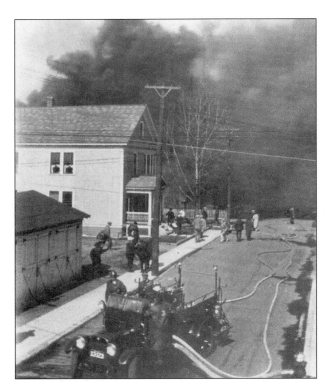

Hudson's pumper was on the scene of a fire on Worcester Street in Nashua in May 1930. Mutual Aid is provided to all area towns when there is a large incident.

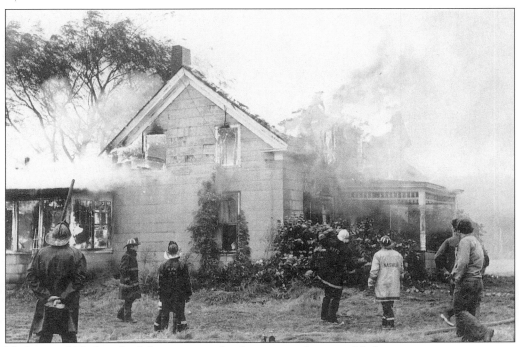

Hudson and Nashua firefighters survey the damage to a house in Nashua.

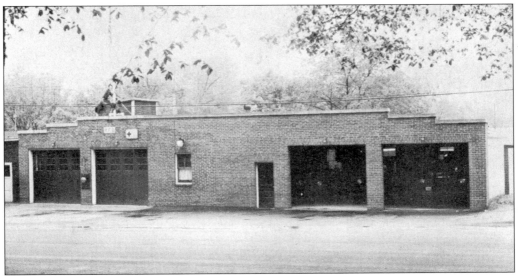

This is the Hudson Fire Department at the House Brothers' Garage on Ferry Street, c. 1924. The building also had an office for the police station, and Harry Connell was both fire and police chief.

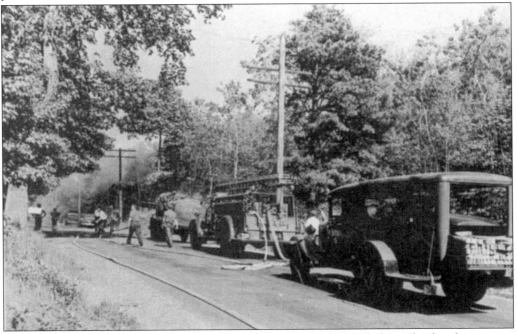

Hudson Fire Department apparatus is shown at the scene of a brush fire. The fire department was manned mainly by call members, who would hear the fire whistle and drop what they were doing to rush to the station. Hudson continues to operate with both full-time and call firefighters out of its three locations at Central Fire Station, Robinson Road Fire Station, and Burns Hill Fire Station. The latter two are call companies. The fire whistle still sounds each day at 8 a.m. and 8 p.m., and still is available for use if the current electronic paging system were to fail.

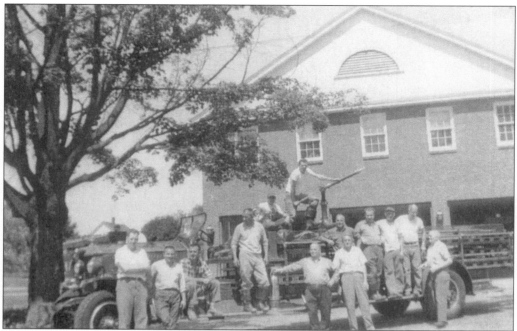

Hudson Fire Department members pose on a fire truck purchased from Nashua. Shown *c.* 1950s are, from left to right, the following: (standing) Dick Burns, Bobby Buxton, George Cady, one unidentified person, Oscar Campbell, Verian Scott, and Elmer McLavey. Those on top of the truck are unidentified.

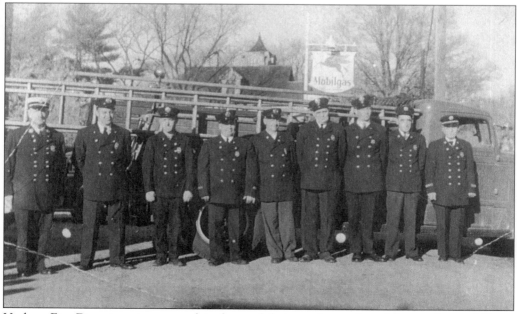

Hudson Fire Department personnel in front of their truck are, from left to right, as follows: Chief Harry Connell, Eddie Parker, Lee Howard, Oscar Campbell, Arthur Fuller, Elmer McLavey, one unidentified person, Arthur Brunt, and Harry Emerson.

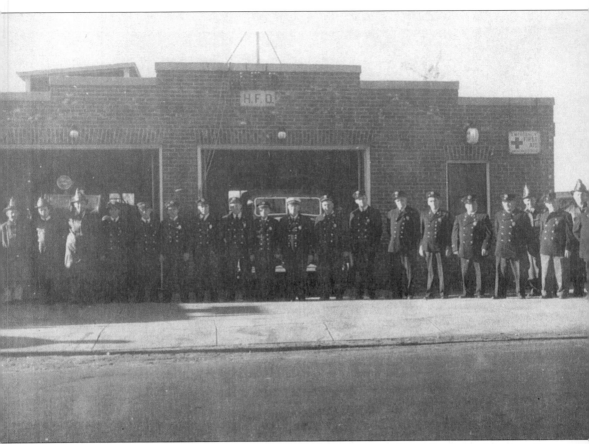

The Hudson Fire Department poses in front of the fire station on Ferry Street in this *c.* early 1940s picture. Included are, from left to right, the following: Lee Howard, Frank Nutting, one unidentified person, Bunny Farmer, one unidentified person, Noyes Connell, Eddie Parker, Harry Emerson, Chief Harry Connell, Joseph Fuller, Ralph Steele, Elmer McLavey, Arthur Brunt, Oscar Campbell, Paul Buxton, Arthur Fuller, Kenneth Abbott, Christopher Gallagher, and Roland Abbott.

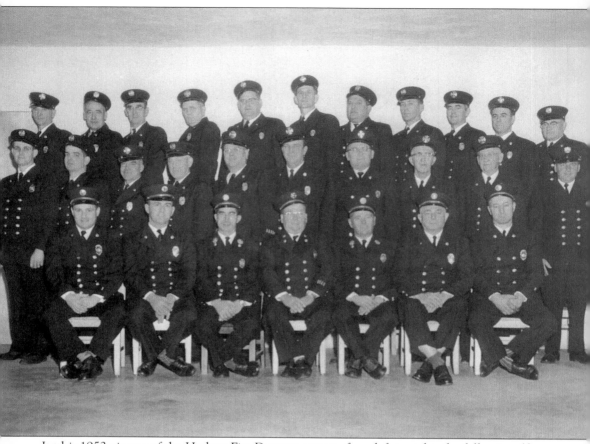

In this 1952 picture of the Hudson Fire Department are, from left to right, the following: (front row) Robert Buxton, George Cady, Winthrop Hannaford, Chief Oscar Campbell, George Fuller, Christopher Gallagher, and J. Edwin Parker; (second row) Harry Chesnulevich, Romeo Morin, Arthur Shepherd Sr., Kenneth Abbott, one unidentified person, Eugene Cherkes, Lee Howard, Arthur Fuller, and Robert Campbell; (third row) Walter Fuller, Arthur Brunt, one unidentified person, Elmer McLavey, Gordon Smith, Leonard Smith, Alfonse Smilikis, George Rogers, Verian Scott, Frank Nutting, and Paul Buxton.

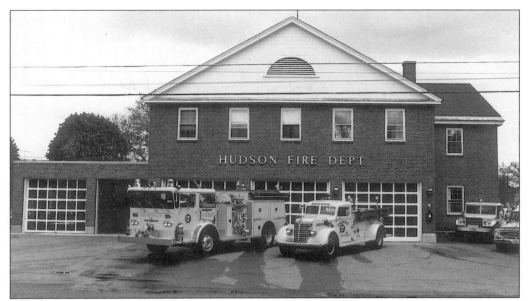

This 1977 photo of Central Fire Station on the corner of School and Library Streets shows the single-story, two-bay addition completed in 1972. The smaller truck on the right, "the Super Lemon," was used as the muster truck and is now owned by the Hudson Firefighters' Relief Association. The American LaFrance pumper on the left, with its lime-yellow paint, was purchased in 1975 and remained in service as Engine No. 3 until 1998.

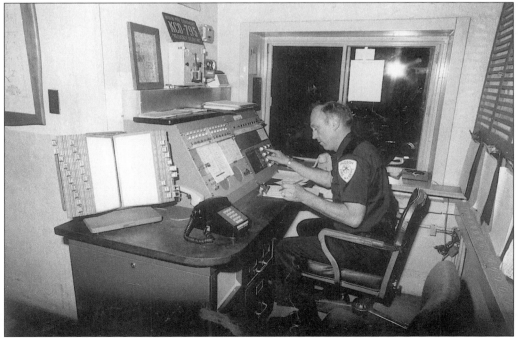

John Abbott dispatches calls at the fire station in 1977.

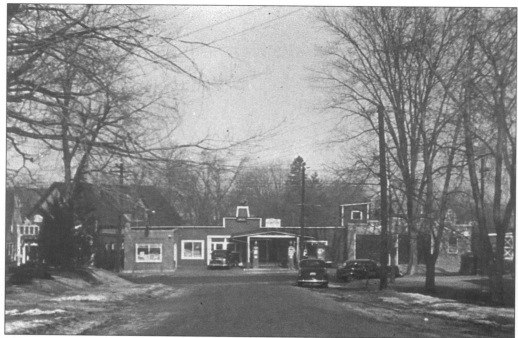

The Hudson Fire Department and Police Station was moved to the House Brothers' Garage on Ferry Street in 1924. Harry Connell served as both fire and police chief.

The Hudson Fire Department building was built in 1952 on the corner of School Street and Library Street. It was designed by architect Leonard Smith, a volunteer firefighter, and built mainly by volunteers and the firefighters themselves. This building also housed the police department and selectmen's office until a new Town building was built adjacent to the station in 1965.

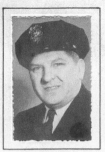

PATROLMAN
ALPHONSE SMILIKIS

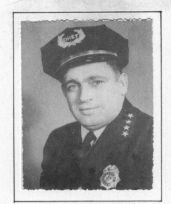

CHIEF
ANDREW J. POLAK

PATROLMAN
LEO GAGNON

PATROLMAN
MICHAEL KAROS

PATROLMAN
EDWARD REYNOLDS

PATROLMAN
RAYMOND PELKEY

PATROLMAN
LEWIS MARSHALL

PATROLMAN
LENARD RAFFERTY

POLICE DEPARTMENT - 1951 - HUDSON, N. H.

MOB

From the early 1950s through the early 1960s, Chief Polak's wife, Stella, worked out of their home as the telephone dispatcher for the two patrol cars. Andrew Polak was police chief for 26 years and retired in 1972.

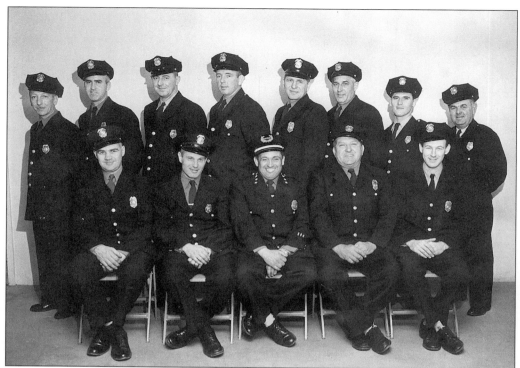

This 1959 photo of the Hudson Police Department includes, from left to right, the following: (seated) Lewis Marshall, Mel Thompson, Chief Andy Polak, Al Smilikos, and Fred Lee; (standing) Don Bowden, Leonard Rafferty, Bill Teichman, Charles Lindsey, Mike Karos, Leo Gagnon Sr., George Forrence Jr., and Ed Donah.

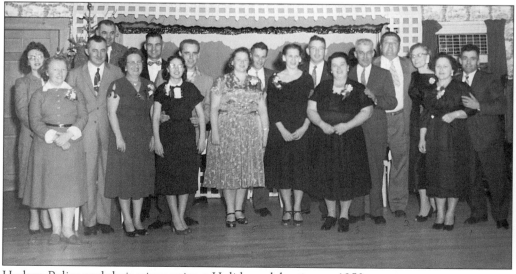

Hudson Police and their wives enjoy a Holiday celebration, c. 1950.

Seven
Locals and Landmarks

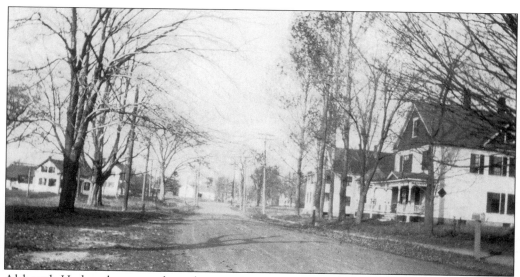

Although Hudson has gone through many improvements and changes through the years, it is comforting to realize that many of the buildings, roads, and homes in the area remain as they were in years past. This is evident in this view of Central Street, looking west, c. 1900.

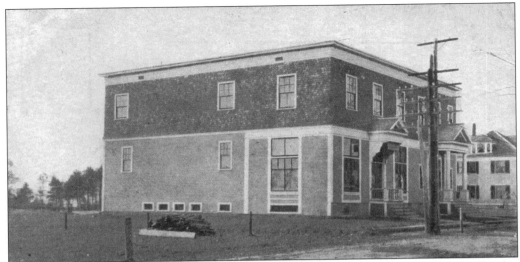

The Odd Fellows Building on Central Street is now known as the American Legion Hall. This building was also the meeting place of many other groups, including the American Red Cross volunteers during WW I. Classes were even held here when schools were overcrowded, until a more permanent solution could be found.

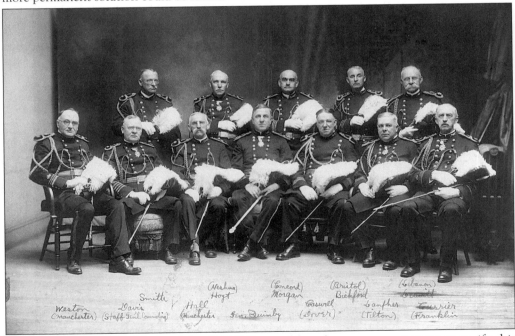

This striking picture is likely of the Odd Fellows, although numerous attempts to verify this have turned up no definitive answer. Although the organization is not named, the people are labeled accompanied by the city or town they represented. Shown are, from left to right, the following: (seated) Mr. Weston from Manchester, Staff General Davis of Hudson, Mr. Hall of Manchester, General Quimby of Hudson, Mr. Caswell of Dover, Mr. Lanfher of Tilton, and Mr. Currier of Franklin; (standing) Dr. H.O. Smith of Hudson, Mr. Hoyt of Nashua, Mr. Morgan of Concord, Mr. Bickford of Bristol, and Mr. Leavitt of Lebanon.

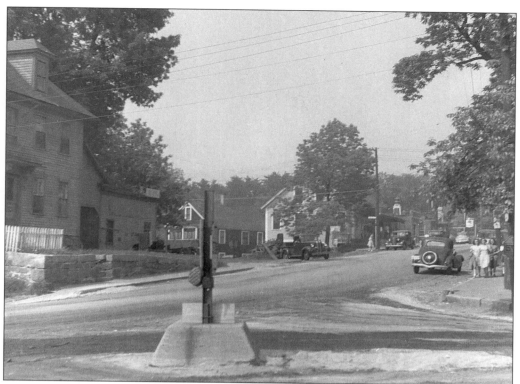

This is the intersection of Ferry Street and Central Street as it appeared in 1946.

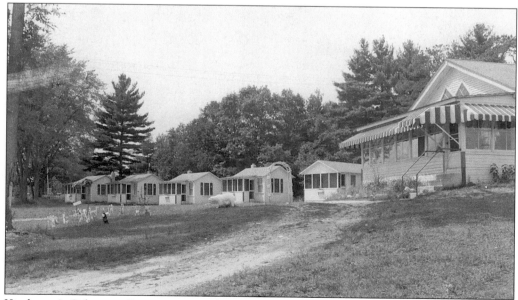

Kitchener's Cabins on Route 111 were located where a mobile home park is now.

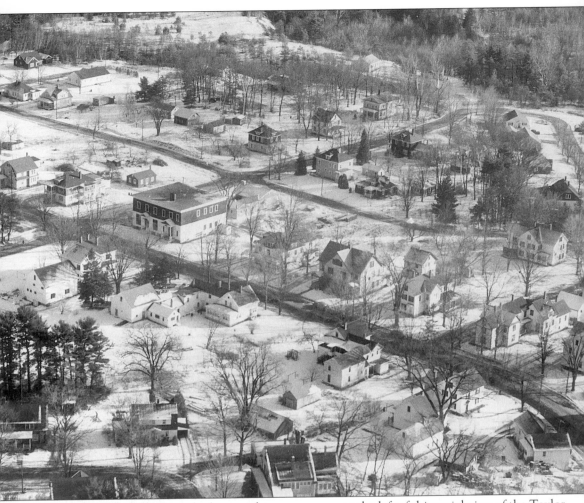

Central Street runs from the lower right corner across to the left of this aerial view of the Taylor Falls Bridge area from the 1950s. The large building near the center of the photo is the American Legion Hall, formerly the Odd Fellows Hall.

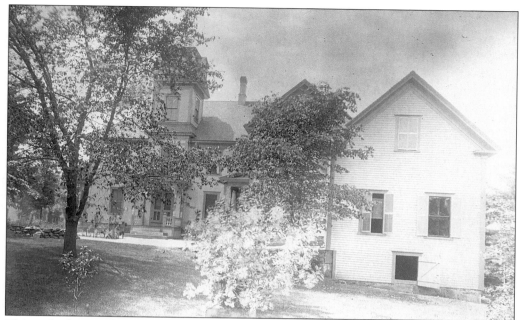

This is the home of Mrs. George (Annabel) Andrews and her daughter Maude. Maude was a librarian at the location above the Baker Brothers' store for six years until 1903, when a family tragedy occurred. A train returning from Canobie Lake Park in Salem, New Hampshire, collided with another train, killing George Andrews and seriously injuring Annabel. Mr. Andrews had been a prominent citizen, serving as postmaster, selectman, and state representative.

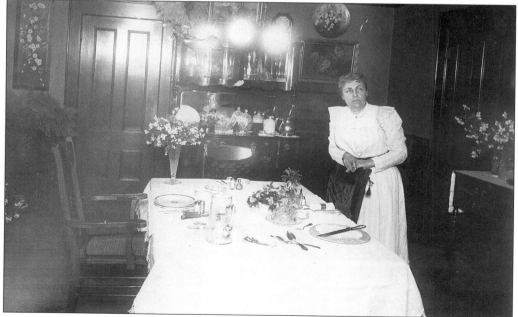

Mrs. George Andrews is shown in the dining room of her elegant home.

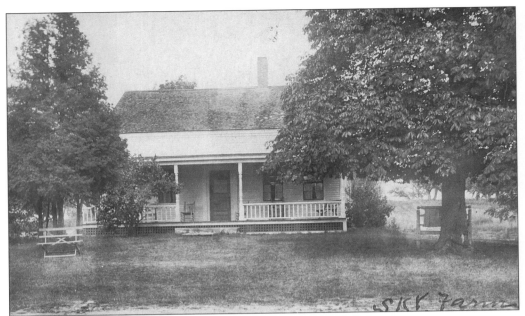

A photograph of Sky Farm on Bush Hill Road was taken in 1886.

Pictured is the home of Captain Joseph Blodgett and his wife Sarah Spaulding Blodgett on what is now Lowell Road. Pictured, *c.* 1899, is Miss Vinnie Blodgett, daughter of Austin and Sarah (Davis) Blodgett. She was the granddaughter of Captain Blodgett.

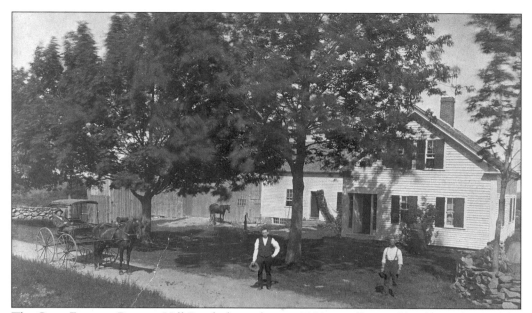

The Cross Farm on Barretts Hill Road, shown here *c.* 1900, is still owned by descendants of the Cross family.

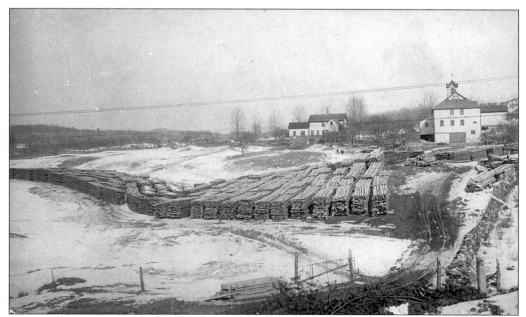

This is a view of the rear of the Haselton barn on Bush Hill Road.

These men were starting to lay out the construction of River Road in this *c.* 1900 image. Trolley car tracks that are visible carried passengers from Nashua to Lowell in the early 1900s.

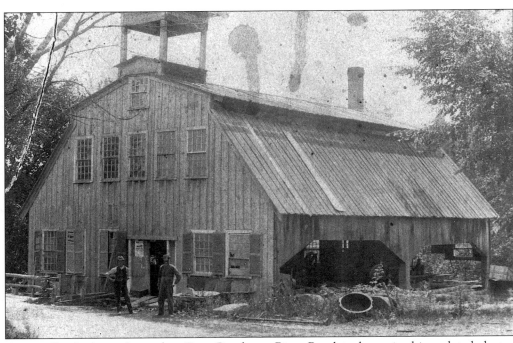

A sawmill, which was located on Eayrs Pond near River Road, is shown in this undated photo.

This portrait is of descendants of the Hills family, who were some of the earliest settlers of Hudson. Pictured in this 1912 photograph are little Virginia Andrews, her father Howard Andrews, grandfather Arthur Andrews, and great-grandfather Robert Andrews. The Andrews family first settled in what was known as Nottingham West, now Hudson, in the late 1700s and became very involved in the community.

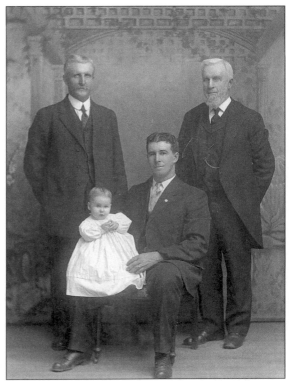

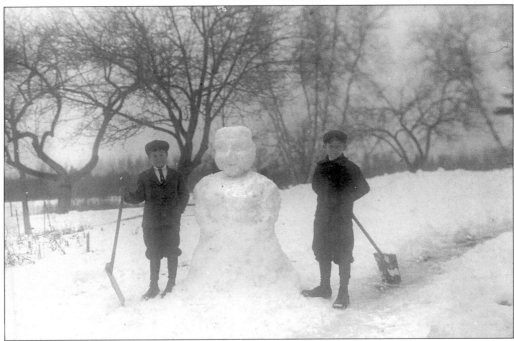

In between shoveling jobs, c. 1920, Gothard Jewell and W.H. Peavey found time to sculpt an elaborate snowman and perhaps even used their shovels as sleds.

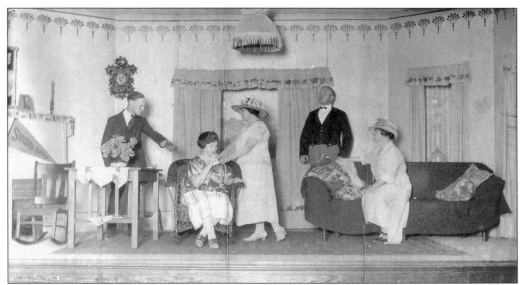

Before the popularity of television, stereos, and computers, people were more likely to become involved in various groups and organizations in town. This 1920s photograph of the Hudson Players shows, from left to right, the following townspeople practicing for their next performance: Ted Moore, Ruth Wood, Almeda Bassett, Sidney Baker, and Louise Wilshire.

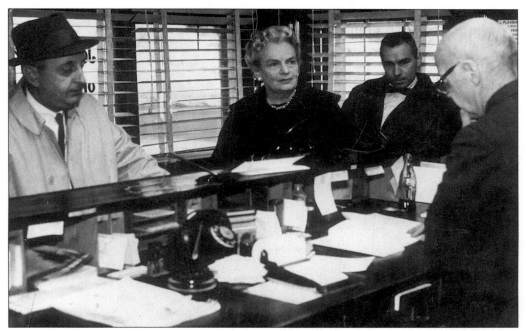

Town Clerk John E. Baker tends to business with Ernie McCoy on the left, Maude French in the center, and an unidentified man on the right, c. 1960. The town clerk's office was located in a small cottage-type building on the corner of Baker Street and Derry Road, until the new town hall was built on School Street in 1965. John Baker was town clerk from 1940 to 1966, when he died at age 65.

The ground was prepared for the Town Office Building, which opened in 1965. It housed the Selectman's Office as well as a conference room and public meeting hall.

Prior to the groundbreaking, Hudson's Town Clerk's office was located on the corner of Baker Street and Derry Road, and the police department shared space with the fire department. In 1974, an addition to the Town Office Building gave the police a communications room, several offices, cells, and a squad room. A spacious new police department facility was built in 1995 off Route 111 on Constitution Drive.

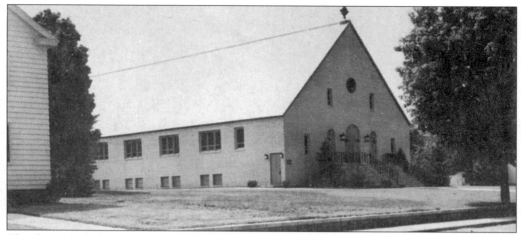

The first Mass in the newly built St. John the Evangelist Church on Library Street was celebrated on Easter Sunday in 1950. Prior to completion of St. John's, which was the first Catholic church in Hudson, Masses were held in the auditorium of nearby Dr. H.O. Smith School.

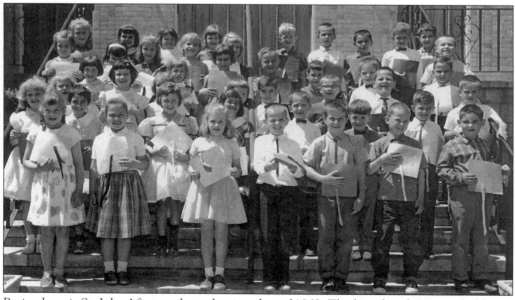

Posing here is St. Johns' first grade graduating class of 1962. The list of graduating girls (shown on the left side of the image) included Robin House, Ellen McGraw, Debra May Perry, Barbara Rowell, Theresa Landry, Sandra Lee Galipeau, Claudette Nadeau, Laurie Chaput, June Neskey, Deborah Bolton, Colleen Burbine, Carol Briand, Marie MacDonald, Gail Pitts, Lynn Treble, Brenda Desrosiers, Karen Laquerre, Susan Alexnovitch, Donna Trainger, Donna Kulingaski, Linda Miller, and Beth Clark. The list of graduating boys (shown on the right side of the image) included Mathew LaRose, Alan Chesnulevich, Rosaire Gauthier, Thomas Nikan, Jeffery Gass, Randy Mitchell, Kevin Shea, Lionel Levesque, William Kenette, Richard Duplease, Paul Berube, Paul Buxton, Richard Lambert, Daniel Keenan, Alfred Jacques, Glenn Fraser, Roger Cloutier, Kevin Savage, David St. Laurent, and Matthew Pelletier.

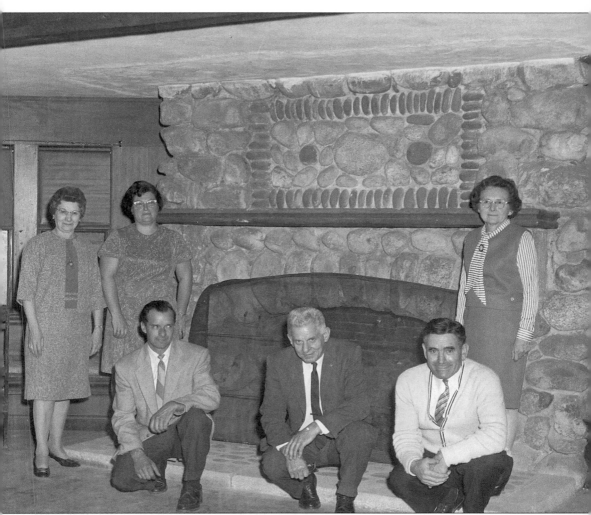

Members of the Hudson Historical Society pose in the meeting room of Alvirne Hills House in this 1968 photograph. Members shown are, from left to right, as follows: Zoula Rowell, Doris Provencher, Fred Rowell, Robert Hill, Louis Pecce, and Gretta Pecce. Robert Hill was the first president of the Society. The Society was formed in 1966 to preserve Hudson's past for the benefit of its future. Its first task was to restore the Hills House, now home to the Society's collections.

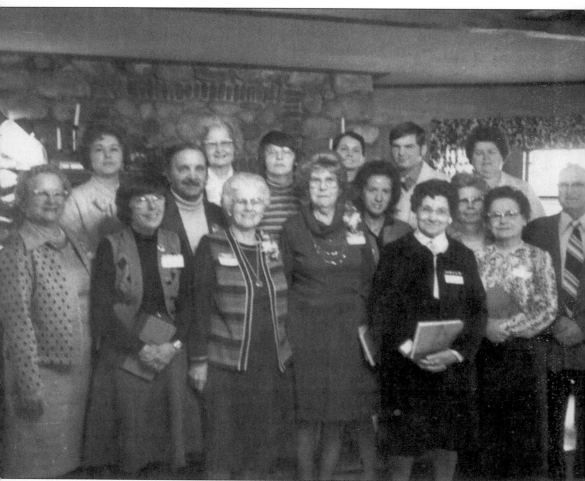

In 1977, a group of Hudson Historical Society members published *Town In Transition: Hudson, New Hampshire 1913–1977*. This book was a continuation of Kimball *Webster's History of Hudson, New Hampshire*. Members of the Hudson History Committee, pictured from left to right, are as follows: (front row) Ella Connell, Dorothy Spalding, Hazel Buxton, Ruth E. Parker, Barbara Abbott, Zoula Rowell, Shirley Benner, Mildred Chalifoux, and Fred Connell; (back row) Claire Smith, Kenneth Clark, Natalie Merrill, Ruth M. Parker, Doris Ducharme, Shawn Jasper, and Arlene MacIntire.

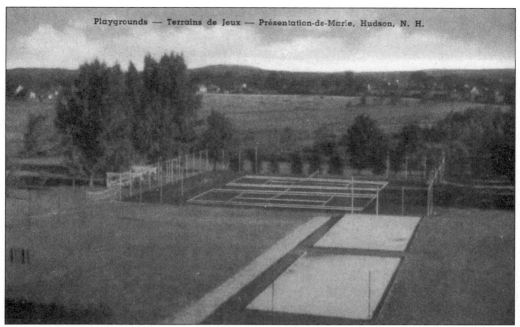

Playgrounds — Terrains de Jeux — Présentation-de-Marie, Hudson, N. H.

The Presentation of Mary Academy opened on Lowell Road in 1924, and continues to teach kindergarten through eighth grades. The tennis courts are shown in this 1930s photo.

The Fairview Nursing Home on Lowell Road was built in 1952 and continues to provide excellent nursing care to its elderly residents.

This 1890s picture of Elmer Blodgett certainly shows that he was not someone to cross. Elmer was a descendant of Joseph Blodgett, one of the earliest settlers of the territory now known as Hudson, then known as Dunstable. The original Blodgett garrison was built at the River Road end of town, as protection against Native American attacks.

In July 1925, the quiet town of Hudson was stunned by the murder of the two elderly Gillis sisters in their home on the corner of Library and Central Streets, which now houses a business. Two juveniles were apprehended and found guilty of the crime and served time in jail. During that time, County Solicitor Hazelton, third from left standing in the rear, and Inspector Edward McCarthy standing on the far right, posed with other police and reporters from several cities.

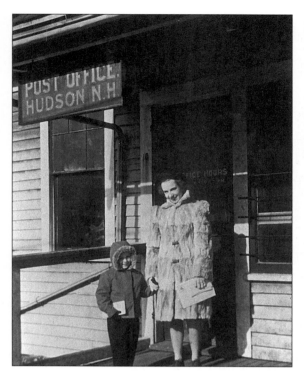

Ruth Montgomery Fullerton and J. Roger Cunningham pose in front of the Hudson Post Office in the Morey Building on Ferry Street in February 1944. The post office was a central location, particularly during WW II when people sent letters and packages to the servicemen and eagerly awaited replies. The Morey building continued as the home of the post office from 1923 until 1959, when it moved into a new building on the corner of Derry and Highland Streets.

The original Morey building was torn down and this building, the Hudson Post Office, was erected on the same site on Ferry Street after WW II. Then the post office was moved to a new building on Derry Street in 1959. The post office has two locations now, the offices on Executive Drive, and the main branch in Shop 'N Save Plaza on Derry Street.

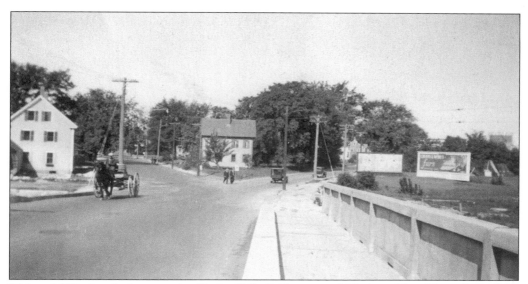

This *c.* 1920 view looks over the Taylor Falls Bridge toward Nashua, New Hampshire, from the Hudson side. East Hollis Street is on the left and Bridge Street is on the right. The home in the center, which has since been torn down, was the home of siblings Cleon and Marion Burnett. *c.* 1920.

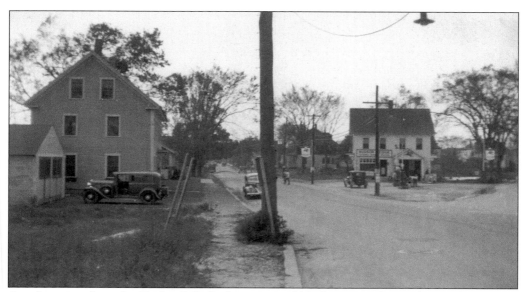

Another view from the Taylor Falls Bridge is toward Nashua several years later. The Burnett House later was converted into the Hudson Bridge Filling Station, as shown here *c.* 1940.

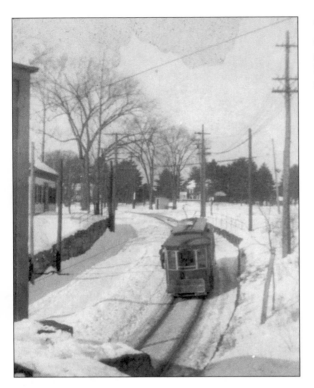

This trolley travels on tracks cleared of snow on Lowell Road in this winter scene. Central Street is in the background. The house and stone wall still stand on Lowell Road.

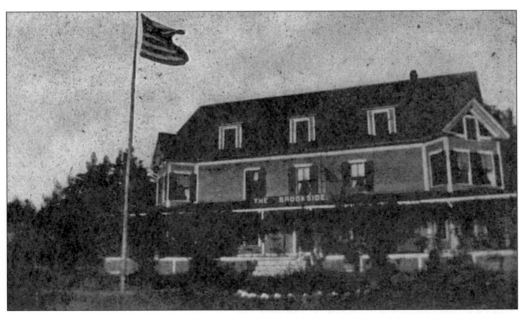

The Brookside was an Inn operated by the Stearns family near the Litchfield/Hudson town line, c. 1930.

As a young man of 21 in 1849, Kimball Webster left Hudson, New Hampshire, to join the gold rush in California. He kept a diary of his experiences and travels, and wrote *The Gold Seekers of '49—A Personal Narrative of the Overland Trail and Adventures in California and Oregon from 1849 to 1854*. The book was published in 1917, one year after Webster's death in 1916, with a foreword by George W. Browne. Kimball Webster began organizing *The Gold Seekers of '49 . . .* for publication while he was in his early 80s, after having spent more than 50 years compiling information for *The History of Hudson, New Hampshire*.

Kimball Webster was born in Pelham, New Hampshire, in 1828 but moved with his family to Hudson as a young child. After his adventures out west from 1849 to 1859, he returned to Hudson and became very involved in the town, serving as town moderator from 1891 through 1894. Perhaps his greatest contribution to Hudson was his 50-year research and compilation of *The History of Hudson*, which was published in 1913. This large volume continues to be the main source of information about Hudson's past, and his careful attention to detail certainly was invaluable to the research of this book. Kimball Webster married Abiah Cutter in 1857 , who died on February 2, 1916. Kimball Webster died on June 29, 1916. The Hudson Historical Society published an update to *The History of Hudson* in 1977, called *Town in Transition- Hudson, New Hampshire*.

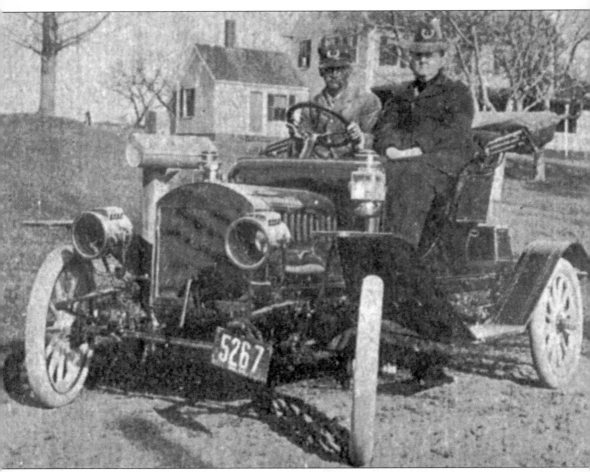

Will Stearns and an unidentified passenger pose in Stearn's 1911 Maxwell Roadster, which he used to deliver mail in Hudson. Stearns worked for the Hudson Post Office for many years from the late 1800s through the 1920s. He lived near the Hudson/Litchfield town line near the Brookside Hotel, which was run by his family, also pictured in this book. The 1911 Maxwell was the only car Stearns ever owned, and he allowed no one else to drive it. Upon Stearns's death in 1943 at the age of 84, his relatives sold the car to the Goyette Museum in Peterborough, New Hampshire. The car remained at the Goyette Museum until 1959, when a man named Robert Booth purchased the car from Mrs. Goyette, who also gave Booth this picture. In 1999, Mr. Booth, now living in Georgia, advertised in a New England Magazine that he was willing to swap the 1911 Maxwell for old New England clocks. Chairman of the Historical Society Shawn Jasper spotted the ad, and a five-month quest to fulfill this trade began. A Levi and Abel Hutchins clock from the early 1800s was found through the efforts of Society President David Alukonis, and purchased for $12,000 with the assistance of donations. The Swap of the Century took place on July 9, 1999, at the Hills House. The car will now be restored by the Society.

Eight
NEIGHBORS SINCE 1916

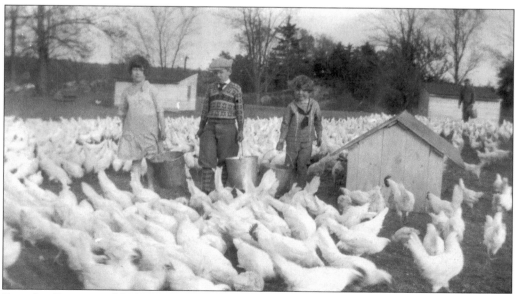

Dorothy, Forrest, and Robert Jasper feed the chickens on the home farm of Jasper Poultry Farms on Derry Road, now called Old Derry Road, about 1927. Their father, Grant Jasper, purchased Mapleside Poultry Farm in 1916 and later changed the name to Jasper Poultry Farms as he expanded the business.

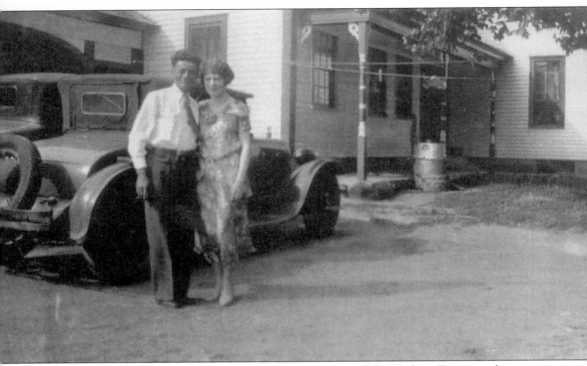

Emery Henry and Marion (Lambert) Nadeau are in front of the Nadeau Farm on what is now Old Derry Road. The Lamberts and then the Nadeaus raised dairy, poultry, and swine, though the chickens and pigs were phased out by 1954. Marion Lambert married Henry H. Nadeau on October 6, 1935, and they eventually purchased the farm from her father in 1940. The farm is now owned and operated by Marion and Henry's son and grandson, both named Emery A. Nadeau.

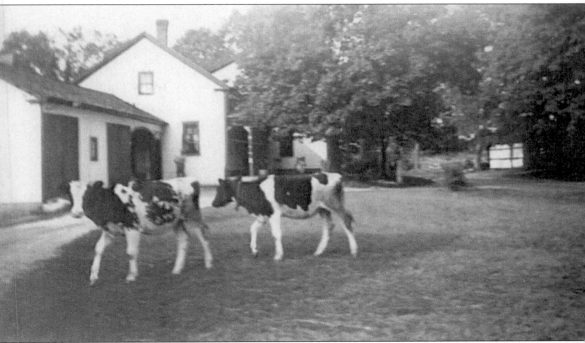

These two Holstein heifers are in front of the Nadeau Farm. The shed and the ell of the house burned in the 1940s after oily rags exploded in a stove in the shed, but the main portion of the house was saved. The house, believed to have been built in the late 1700s, served at one point as a tavern, since it was on the main road between Nashua and Derry.

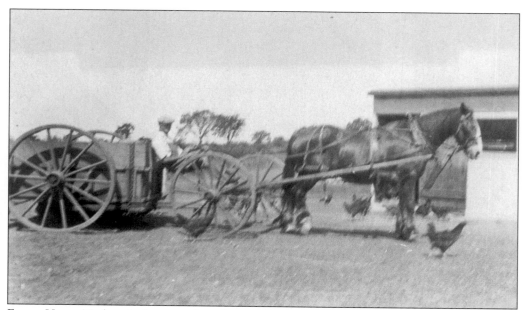

Emery Henry Nadeau is shown making his rounds to the colony houses out on the range. The farm used to have cows, chickens, and pigs, but the current Nadeau Farm continues strictly as a dairy farm.

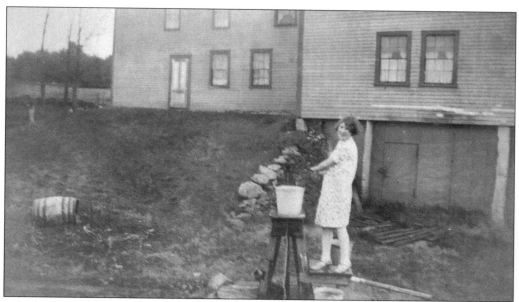

Marion (Lambert) Nadeau poses at the water pump at the rear of the house. Her father Joseph Lambert bought the farm in 1902. It was formerly the Jackson E. Greeley farm, who was the brother of Stephen Greeley, who owned the nearby farm at what is now 36 Old Derry Road.

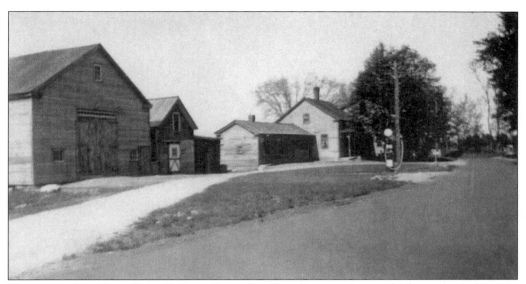

This is another view of the Nadeau Farm, showing the main barn, which was torn down in 1964. The smaller barn to the right is still in use, and the Nadeaus continue to operate their dairy farm.

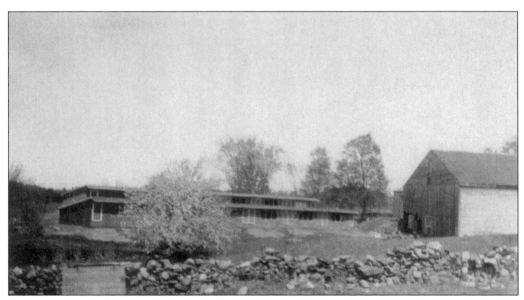

Here is the rear of Nadeau Farm, *c.* 1940.

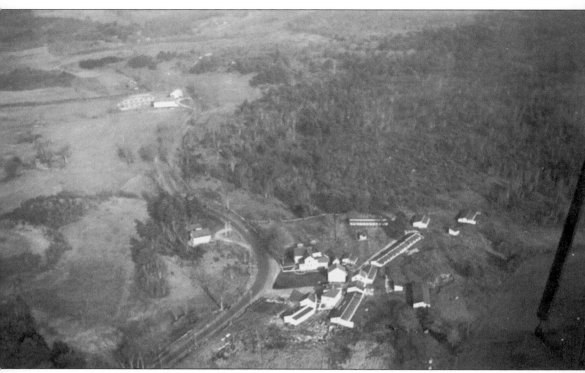

Across the Old Derry Road from the Jasper Poultry Farms is the Number Nine schoolhouse. The Neighboring Nadeau Farm can be seen in the upper left area of the picture. The Jasper and Nadeau Farms are approximately less than one quarter of a mile from each other.

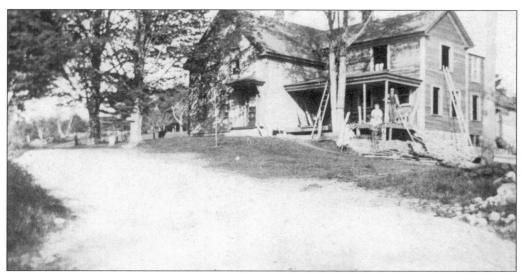

This 1920 photograph of Grant Jasper's home on Derry Road, now the Old Derry Road, shows construction of the enclosed porch and the addition. Derry Road is in the foreground.

Jasper Poultry Farms bred chickens to be sold to other farms for breeding purposes, although there were always eggs for cooking. The poultry business was a huge industry in the early part of the 1900s, and Grant Jasper expanded the business to be one of the top three producing Farms in New Hampshire.

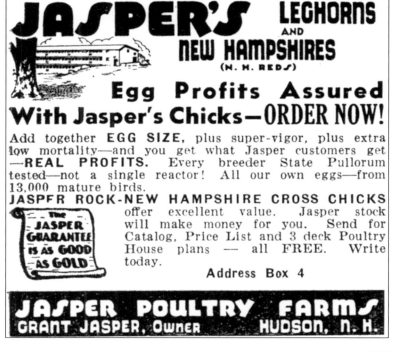

JASPER'S LEGHORNS AND NEW HAMPSHIRES (N. H. REDS)

Egg Profits Assured With Jasper's Chicks—ORDER NOW!

Add together EGG SIZE, plus super-vigor, plus extra low mortality—and you get what Jasper customers get —REAL PROFITS. Every breeder State Pullorum tested—not a single reactor! All our own eggs—from 13,000 mature birds.

JASPER ROCK-NEW HAMPSHIRE CROSS CHICKS offer excellent value. Jasper stock will make money for you. Send for Catalog, Price List and 3 deck Poultry House plans — all FREE. Write today.

THE JASPER GUARANTEE IS AS GOOD AS GOLD

Address Box 4

JASPER POULTRY FARMS
GRANT JASPER, Owner HUDSON, N. H.

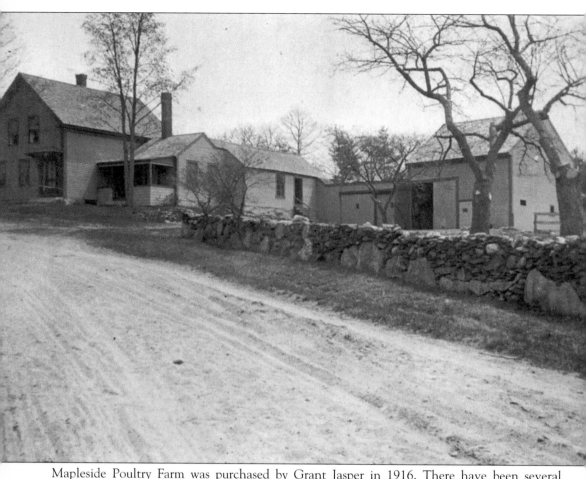

Mapleside Poultry Farm was purchased by Grant Jasper in 1916. There have been several additions to the home since this picture was taken c. 1920s, and the stone wall no longer exists.

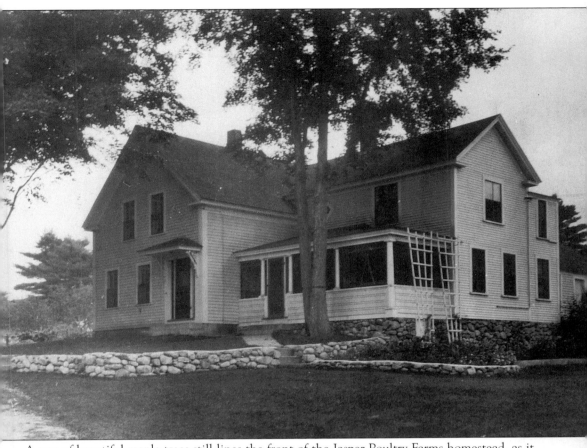

A row of beautiful maple trees still lines the front of the Jasper Poultry Farms homestead, as it did in the 1920s. Grant Jasper purchased the farm, previously called Mapleside, in 1916 from Charlton Brain.

This winter scene is of Jasper Poultry Farms in 1939. The smaller house on the right was used as the office, with a hatchery in the basement, and pens for selective breeding in the attached shed. The addition on the left of the main farmhouse was completed in 1939. Jasper Poultry Farms continued in the business until 1972, and was once the third largest poultry farm in New Hampshire. At its peak in 1969, there were 60,000 birds in four locations on Old Derry Road. During its years of operation, approximately 160 million eggs were produced.

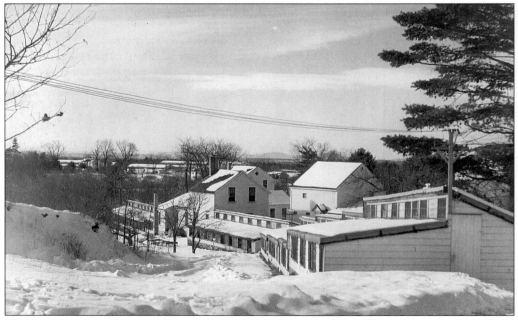

This is a view from the rear of Jasper Poultry's home farm in 1939. The single-storied buildings with the many windows are the early style hen houses, built between 1909 and the early 1920s. In the background to the left, the Nathaniel Hills Jr. home is visible, purchased by Grant Jasper in the 1920s. Also visible in the same area are the newer style hen houses, built during the 1930s.

Grant Jasper and two of his children, Dorothy and Forrest, are pictured on the lawn of the home farm in this 1922 photo.

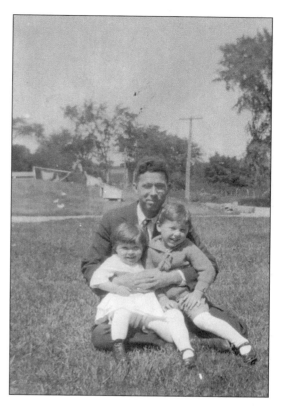

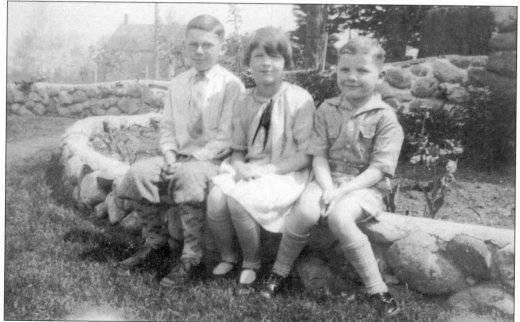

Forrest, Dorothy, and Robert Jasper pose for a picture at the homestead on May 30, 1928. The Number Nine Schoolhouse is visible in the background.

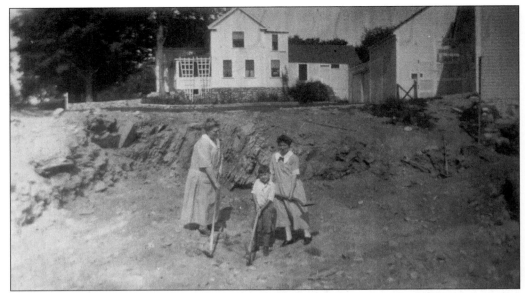

With Jasper Poultry's home farm in the background, three ambitious workers help dig the cellar hole for the hatchery and office in 1925. Pictured are, from left to right, the following: Sarah (Grant) Jasper, Grant's mother; Forrest Whitney Jasper, Grant's son; and Bernice Louise Jasper, Grant's wife. Grant Jasper's father, Arthur, caught pneumonia digging the cellar hole and died from his illness.

Forrest, Dorothy, and Robert Jasper assist in digging the cellar hole for the hatchery and office building next to the home farm in 1925. This house later became the home of Shawn Jasper and his wife, after their marriage in 1992.

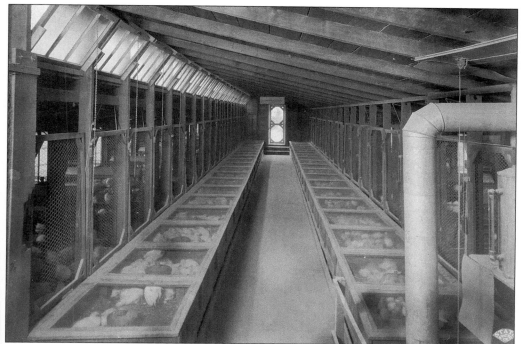

This is a view from the inside of Jasper Poultry Farms brooder house, built by the previous owner, Mr. Brain, about 1910. This was unique for its time in that it had a coal-fired boiler that sent hot water to the individual brooders to supply warmth to the young chicks. The chicks were released in stages as they grew, starting out in the smaller pens, then gradually being released into the outside areas during the day.

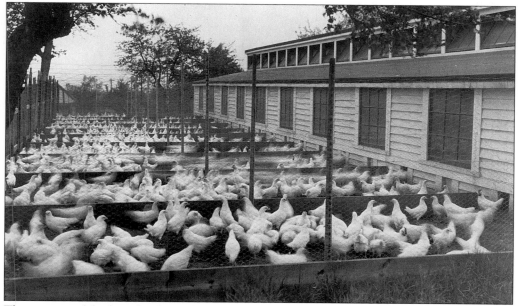

The exterior of the brooder shows the pullets, or young hens. The Number Nine schoolhouse is in the background.

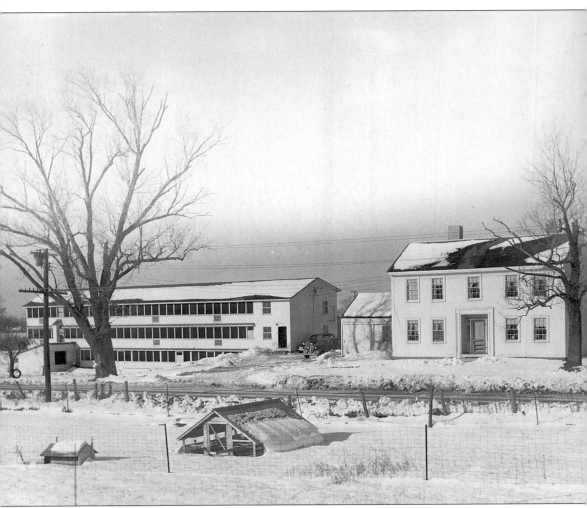

The Nathaniel Hills Jr. Farm, on what is now Old Derry Road, was purchased from the widow of Franklin Hills by Grant Jasper in the early 1920s. After this purchase, Grant Jasper changed the name of his business from Mapleside Poultry Farm to Jasper Poultry Farms, and this location became known as annex number one. The original Hills' barn, situated where the large three-story hen house is in the picture, was destroyed by fire from a carelessly discarded cigarette in the 1930s. The house shown here, c. 1940, was destroyed by fire in January 1947. This part of Hudson was originally in Londonderry, New Hampshire. One of Nathaniel Hills Jr.'s sons fought in the Revolutionary War at the Battle of Bunker Hill, and the Hudson Historical Society possesses the original letter he wrote to his parents after the battle.

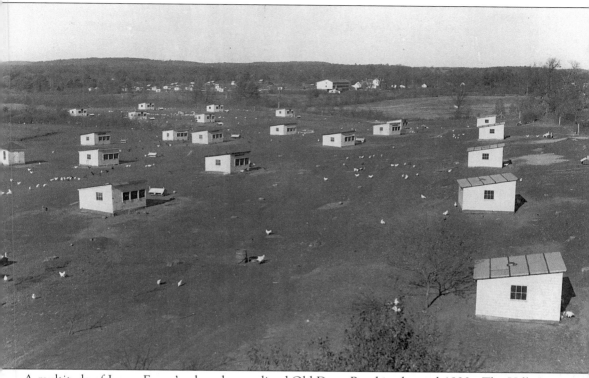

A multitude of Jasper Farms' colony houses lined Old Derry Road in the mid-1930s. The Hills Farm, annex number one, is in the background. Old Derry Road is visible in the top right of the picture. There were 56 of these houses on the farm, and each held a coal fired brooder stove, which had to be fed twice a day. The chicks were placed in them at one day old and the temperature needed to be maintained at 100 degrees, which was gradually reduced over a six-week period. Each of these buildings was moved by truck to a new field every year, to prevent the spread of disease and to allow the fields to recover. In March 1949, hot ashes were placed in a woodchuck hole, resulting in a brush fire that destroyed 50 of the 56 buildings, and killed 10,000 baby chicks.

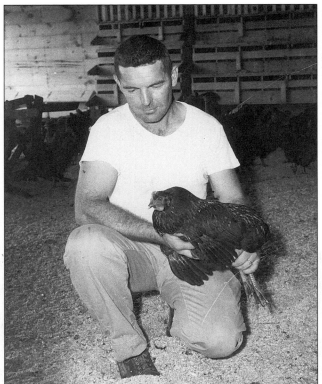

Robert Jasper is shown here with one of "the girls" at Jasper Poultry Farms. Robert Jasper was born in 1922 and attended school at the Number Nine schoolhouse until it closed in 1932. He married Reita (Newton) Jasper in 1958 and they have two children, Shawn (b. 1959) and Maria (b. 1962). Shawn and his wife Laurie (Lyons) Jasper's daughter Sarah Jean (b. 1994) is the fifth generation of Jaspers to live in Hudson on the homestead.

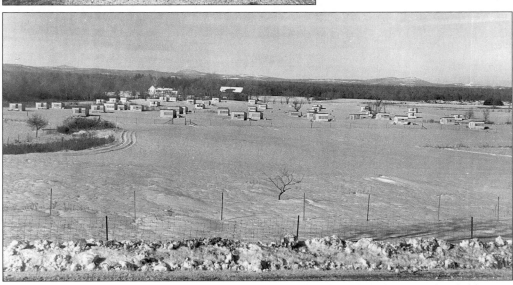

Old Derry Road is in the foreground of this c. 1940s view of the colony houses. This field is east of 34 Old Derry Road. The location of the building in this picture is currently the sight of the Sander's facility on Route 102. The Fuller Farm is shown in the background, which was burned down by the Hudson and Litchfield Fire Departments as a training burn in the mid-1980s, and is now the location of the Sander's entrance on Route 102. The mountains in the background are no longer visible from Old Derry Road.

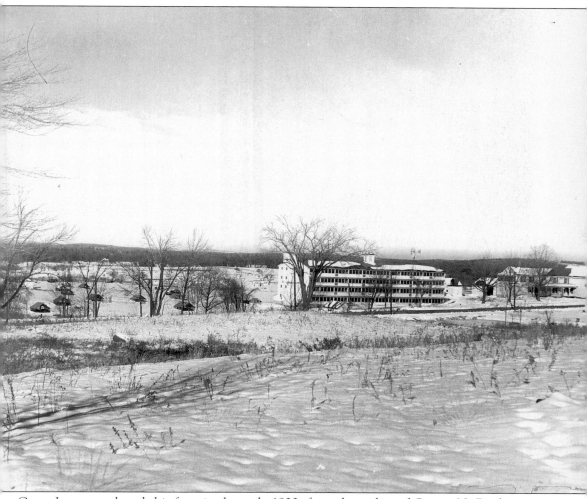

Grant Jasper purchased this farm in the early 1930s from the widow of George N. Dooley, a former Hudson selectman from 1910 to 1912. The original portion of the house was built by Deacon Roger Chase in 1754. Deacon Chase was the last known owner of the Hills Garrison on Webster Street, which no longer exists. Because the farmhouse was built of used timbers, it is possible that some of this material came from the Hills Garrison. Deacon Chase sold the farm to Henry Hills Jr., whose son William later owned the house and served as a selectman in the 1820s. Stephen Greeley purchased the property and was a selectman during the 1840s, 1850s, and 1860s, as well as a state representative in 1864. The windmill was installed by George Dooley prior to there being electricity on the road. It was situated on top of a well and pumped the water up a hill to a cistern, which then provided gravity-fed water to the house and barn. The main part of the four-story hen house is the original barn constructed of hand-hewn timbers, some of which are over 55 feet in length. The barn is equipped with an 1888 freight elevator that was installed when the barn was expanded in the 1930s. This building held 5,500 laying hens and was considered to be a state-of-the-art facility, used as a model in several nationally published poultry manuals of the 1930s and 1940s. The farm is currently owned by the family of Hudson Selectman and former State Representative Shawn N. Jasper.

ADDITIONAL READINGS AND RESOURCES

The Hudson History Committee. *Town in Transition-Hudson, New Hampshire, 1913–1977*. Canaan, New Hampshire: Phoenix Publishing, 1977.

Nash, Gerald Q., Sandra J. Martinson, and Roland A. Marchand. *The Vital Records of Hudson, NH, 1734–1985*. Bowie, Maryland: Heritage Books, Inc., 1997.

Webster, Kimball. *The Gold Seekers of '49*. Manchester, New Hampshire: Standard Book Company, 1917.

Webster, Kimball. *Webster's History of Hudson, New Hampshire, 1673–1913*. Canaan, New Hampshire: reprinted for the Hudson Historical Society, Inc. by Phoenix Publishing Company, 1977.